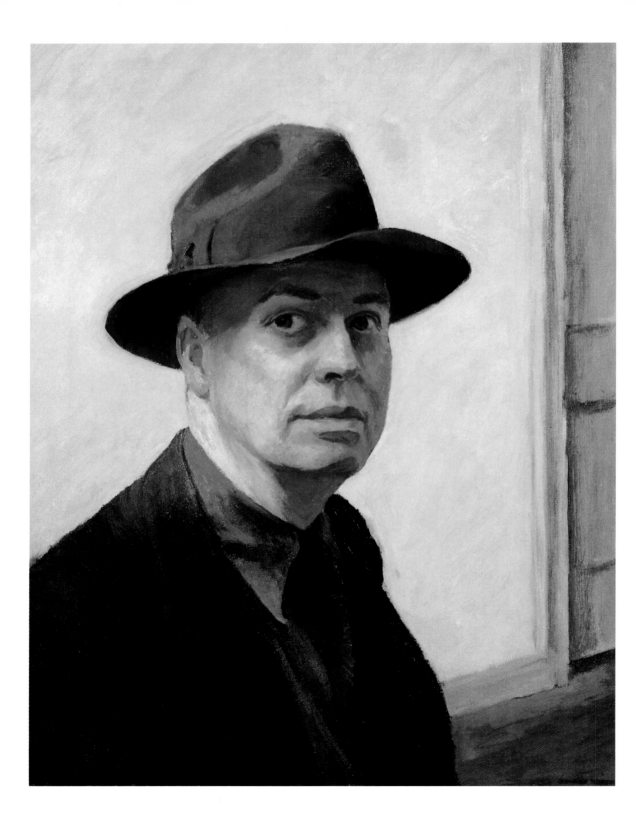

Rolf Günter Renner

EDWARD HOPPER

1882–1967

Transformation of the Real

BARNES
&NOBLE
BOOKS
NEW YORK

This edition published by Barnes & Noble, Inc.,
by arrangement with Benedikt Taschen Verlag GmbH

2000 Barnes & Noble Books

M 10 9 8 7 6 5 4 3 2 1

© 2000 Benedikt Taschen Verlag GmbH
Hohenzollernring 53, D–50672 Köln
www.taschen.com
Edited and produced by Sally Bald, Cologne
Picture research: Frigga Finkentey
Cover design: Catinka Keul, Angelika Taschen, Cologne

Printed in Germany
ISBN 0–7607–2322–2

Contents

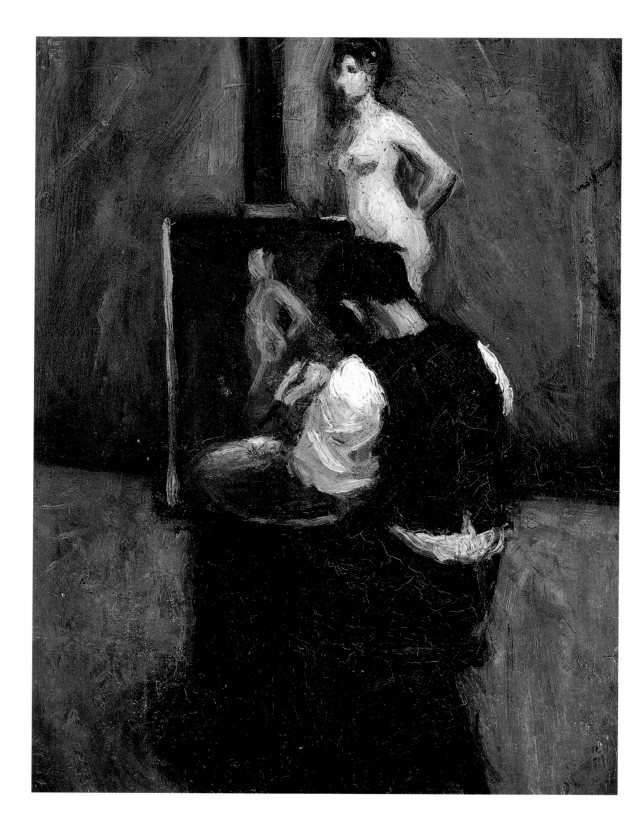

European Beginnings

For most Europeans, Edward Hopper's art confirms a preconceived image of America. Responses to Hopper exhibitions seen in Europe in the late 1970s suggested that this is not due to the painter's style or approach. What is so American is the subject matter. Hopper's American qualities are in the scenes he chose to paint. And those scenes are encoded twofold: Hopper's use of motifs that seem typically American, and his love of realistic detail, are alike defamiliarized. The defamiliarization Hopper subjects his scenes to is intended to reveal the fractures beneath the painted skin of modern life.

This twofold, ambiguous quality has a dimension of aesthetic openness to it. And it explains Hopper's special significance during the heyday of American Modernism. Often enough, the Abstract Expressionism of Jackson Pollock and the New Realism of Edward Hopper are interpreted as the twin poles "of American individualism and artistic integrity."[1]

At times Hopper's realism can be so overdrawn that it opens wide a gap that admits things not actually visible in the work. Or it endows the real with an air of the fantastic. Hopper's view of landscape, for instance, calls to mind the archetypal experience of the Frontier, that meeting of Man and Nature that was so crucial to the American identity and which left its mark not only on the pre-eminent 19th century writers (Hawthorne, Melville, Poe) but also on the pictures of Thomas Cole and of the Hudson River School. And just as the myth of endless natural opportunity became an ossified loss of bearings in Poe and Melville, so too the image of Nature in Hopper's art often undergoes curious metamorphosis. Either it is scored by civilization's many blemishes, by streets and railroad crossings and lighthouses, or those very tokens of civilization appear lost and even endangered in an unspoilt natural setting – an impression conveyed by most of the pictures of houses Hopper painted. For this reason, his paintings tend not to offer us extensive panoramas: rather, they limit the view – and Hopper often substitutes an interior seen through a window, or window prospects limited by houses or other icons of the civilized world, for an unrestricted view of Nature.

Hopper froze archetypal dynamism into rigidity in his American scenes. But of course we must remember that this reversal was not an exclusively American phenomenon; rather, it was a hallmark of modern art. Given the time lag that lay between European aesthetic insights and American, we might compare Hopper's window views and

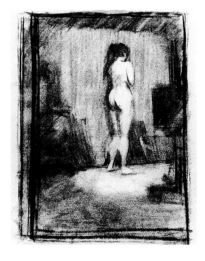

Standing Female Model in Studio, c. 1900–03
Charcoal on paper, 30.8 x 24.1 cm
Collection of Whitney Museum of American Art, New York, Josephine N. Hopper Bequest 70.1560.90

Painter and Model, c. 1902–04
Oil on cardboard, 26 x 20.5 cm
Collection of Whitney Museum of American Art, New York, Josephine N. Hopper Bequest 70.1420

Summer Interior, 1909
Oil on canvas, 61 x 73.7 cm
Collection of Whitney Museum of American
Art, New York, Josephine N. Hopper Bequest
70.1197

natural scenes with similar images European Romantic art had already produced, in an attempt to register stasis in the progress of civilization, and the alienation of humankind from the natural environment. Hopper adapted those images to the needs of fully-developed modernity. The window scenes of European Romanticism had of course not only registered loss but had also provided a visual transcript of scrutiny of the inner self – a scrutiny which induces us to examine ourselves in turn as we consider Romantic paintings. But the transformation of the outer view into an inner, psychological scrutiny also establishes a new iconography. The view of the exterior, once it is blocked, is replaced by a realistic art of the interior, and the landscape beyond the window is replaced by an *interieur paysage* as air and light enter the interior. In twentieth century art, the work of Edward Hopper displays a comparable transformation, a similar transfer of visual interest to the interior. The transfer can already be seen in

early work he painted in Paris, and it unfolds richly in his late work. Hopper too has his eye on psychological factors rather than on the merely visible: representational realism is used as a system of encoded signs that communicate the subconscious basis of conscious perception.

The writer Peter Handke described this effect of realism in his novel *Die Lehre der Sainte-Victoire*. For Handke, what was striking about Hopper's landscapes was not their "dreamlike menace" but a quality of the "desolately real". Still, he also felt they had a "magical" effect, and likened them to "de Chirico's deserted metaphysical squares," to the "desolate moonlit jungle cities of Max Ernst"[2] and to René Magritte's *L'Empire des Lumières II* (p. 90). We might add other comparisons. Edvard Munch's *The Storm* (p. 42), with its faceless figures grouped in the foreground, uses effects of the light to defamiliarize the house and setting, and might reasonably be related to Hopper's *Rooms for Tourists* (p. 43). And Giorgio de Chirico's cityscapes and pictures of towers remind us not only of Hopper's landscapes but specifically of his lighthouses.

To recapitulate: the metamorphosis of realistic mimesis in Hopper's work has psychological and aesthetic reasons. In a letter written in 1939 to Charles H. Sawyer, then Director of the Addison Gallery of American Art, Hopper explained:

"To me, form, color and design are merely a means to an end, the tools I work with, and they do not interest me greatly for their own sake. I am interested primarily in the vast field of experience and sensation which neither literature nor a purely plastic art deals with. [. . .] My aim in painting is always, using nature as the medium, to try to project upon canvas my most intimate reaction to the subject as it appears when I like it most; when the facts are given unity by my inter-

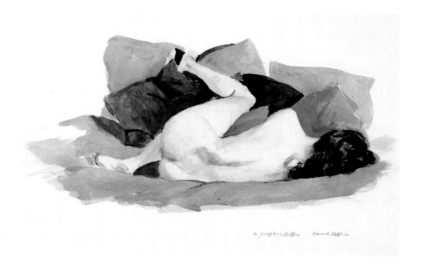

Reclining Nude, c. 1924–27
Watercolour on paper, 35.2 x 50.5 cm
Collection of Whitney Museum of American
Art, New York, Josephine N. Hopper Bequest
70.1089

est and prejudices. Why I select certain subjects rather than others, I do not exactly know, unless it is that I believe them to be the best mediums for a synthesis of my inner experience."[3] This is the source of a certain continuity in Hopper's art, a continuity that informs the very different sketches and techniques of his early and late periods. And underpinning that aesthetic continuity there is a biographical continuity – which was plainly the precondition for his art.

Hopper's life was strikingly quiet and orderly, without abrupt about-turns or upheavals, neither of a psychological nor even of a merely geographical kind. In a sense there is very little to say. Apart from two sojourns in Europe, Edward Hopper lived in New York from 1908 on. For over fifty years, till the day he died, his studio was on the top floor of 3 Washington Square North. The fame that came his way from the Twenties onwards never went to his head, and he lived a quiet life there with his wife Jo (née Josephine Verstille Nivison), whom he had married in July 1924. With the exception of one or two trips, the only changes of scene were afforded by summers in South Truro on Cape Cod, where they bought land in 1930 and subsequently built a house and studio. Hopper's development as an artist was equally unsensational. After the New York School of Art (the Chase School) he did commercial illustrative work and plainly negotiated the transition to more ambitious art without any difficulty. His establishment of a preferred technique, and his increasing concentration on work in oil, similarly occurred with a strikingly unproblematic single-mindedness. If Hopper had private or aesthetic crises in his life, he kept them well under control. It was only on rare occasions that caricatures and drawings suggested psychological tension that the artist was trying to resolve. Some of his pictures point to a fixation on his

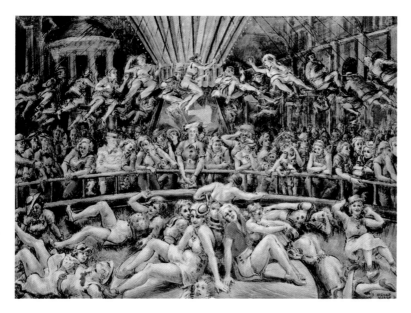

Reginald Marsh
George C. Tilyou's Steeplechase Park, 1936
Egg tempera on fibreboard, 91.4 x 121.9 cm
Hirshhorn Museum and Sculpture Garden,
Smithsonian Institution,
Gift of the Joseph H. Hirshhorn Foundation,
1966

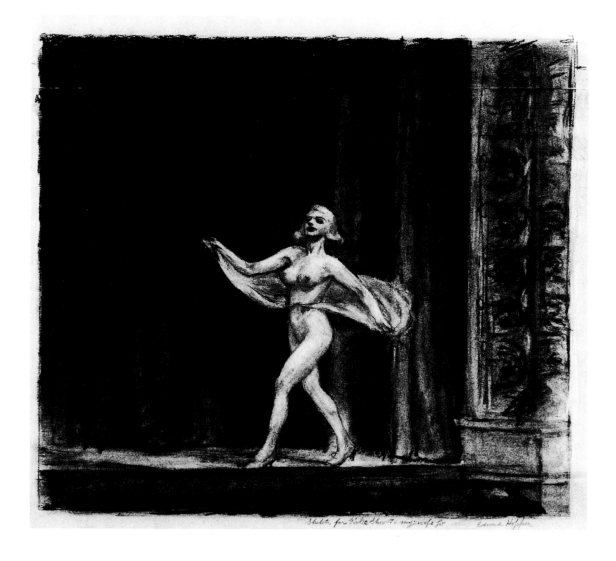

Drawing for *Girlie Show*, 1941
Conte on paper, 33.7 x 38.1 cm
Collection of Whitney Museum of American
Art, New York, Josephine N. Hopper Bequest
70.295

wife: the relationship with Jo, which appeared thoroughly symbiotic
seen from the outside, seems to have had its competitive side – his
wife was not only Hopper's manager and critic, she was also herself a
painter.

Continuity and discipline were naturally Hopper's watchwords
whenever he expressed views on aesthetics. He himself saw his ap-
proach to reality as dictated by biographical continuity, and he felt
that that line of continuity established constants in the most various of
work. In midcareer he wrote: "In every artist's development the germ
of the later work is always found in the earlier. The nucleus around
which the artist's intellect builds his work is himself; the central ego,
personality, or whatever it may be called, and this changes little from
birth to death. What he was once, he always is, with slight modifica-

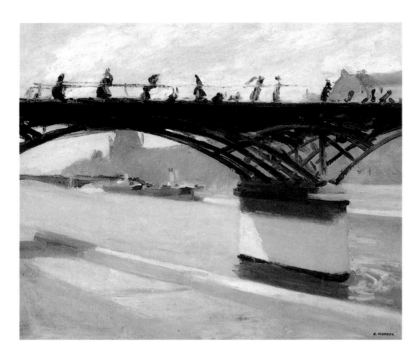

Le Pont des Arts, 1907
Oil on canvas, 58.6 x 71.3 cm
Collection of Whitney Museum of American
Art, New York, Josephine N. Hopper Bequest
70.1181

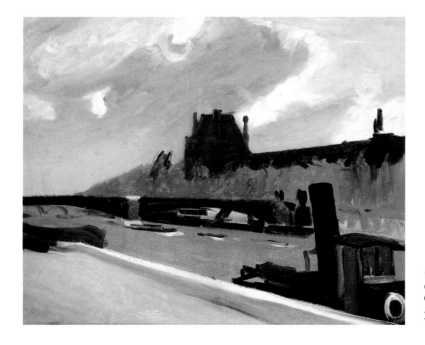

The Louvre in a Thunderstorm, 1909
Oil on canvas, 58.4 x 73 cm
Collection of Whitney Museum of American
Art, New York, Josephine N. Hopper Bequest
70.1223

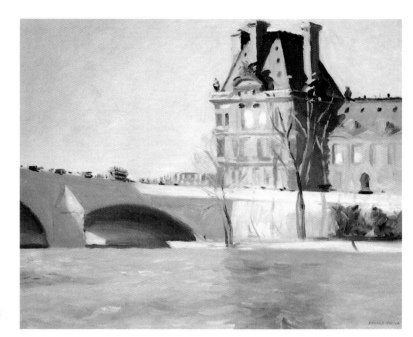

Le Pont Royal, 1909
Oil on canvas, 59.7 x 72.4 cm
Collection of Whitney Museum of American
Art, New York, Josephine N. Hopper Bequest
70.1175

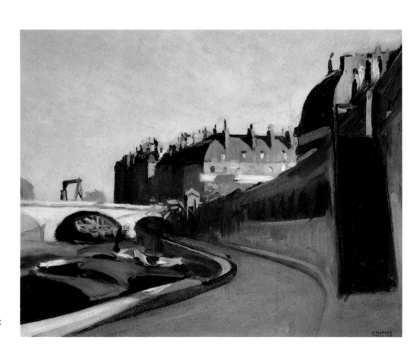

Le Quai des Grands Augustins, 1909
Oil on canvas, 59.7 x 72.4 cm
Collection of Whitney Museum of American
Art, New York, Josephine N. Hopper Bequest
70.1173

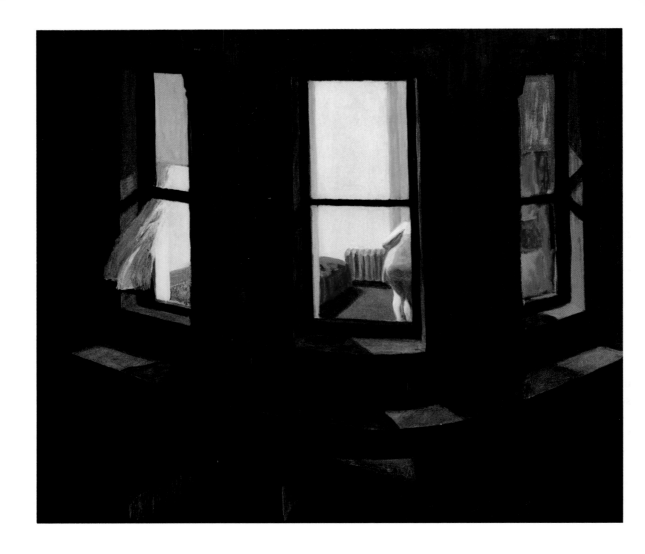

Night Windows, 1928
Oil on canvas, 73.7 x 86.4 cm
Collection, The Museum of Modern Art, New
York, Gift of John Hay Whitney

tion. Changing fashion in methods or subject matter alters him little
or not at all."[4]

Hopper's development as an artist confirms this view (in his own
case) in two respects. On the one hand, his early pictures evolved a
structural polarity between Nature and Civilization which was to re-
main throughout his work. On the other hand, in terms of technique
those same early paintings already show how important light and ef-
fects of light were to be in Hopper's art, to the very end. The artist
baldly told Lloyd Goodrich: "Maybe I am not very human. What I
wanted to do was to paint sunlight on the side of a house."[5]

Not that Hopper was after the merely constructed. He often made
thorough and systematic preliminary studies for his paintings: but his
was not a cool, calculating art – he believed there were subjects that
harmonized with feeling. His attempt to make an intuitive record of

correspondences between inner experience and the painter's ways of seeing, to create harmony between what was seen and what was painted, proceeded from a deep-seated need that clearly ran counter to Modernism: Hopper was out to regain the capacity for authentic experience that had been lost during the course of progress and civilization. Again we might think of Peter Handke, whose writings are based not on construction and interpretation but on the attempt to locate and see something beyond himself, something which some secret desire had long yearned to transform into an inner image.

The psychological component, which became of ever greater significance in Hopper's late work, was occasionally obscured by artistic convention in his early paintings. The American artist's beginnings lay in France. He was nurtured by European tradition. His approach to his art was influenced by Impressionism; and up to about 1910 he repeatedly used subjects connected with the business of painting, the life of the artist, and the studio. *Standing Female Model in Studio* (p. 7), painted in 1900–03, the picture of his own *Bedroom in Nyack*, and above all his early oils *Painter and Model* (1902–04; p. 6) and *Female Nude Getting into Bed* (1904–05) are examples of this tendency.

Hopper's early paintings used dark colours: warm browns, dark grey and black predominated. His technique was partly derived from the Dutch baroque masters Rembrandt and Frans Hals, and also owed something to Edouard Manet. On first acquaintance we might suppose that the work of Hopper's French period has no real connection with the rest of his output; but if we look more closely we will discover features that were to remain characteristic of his art throughout, features that were to acquire an almost obsessive character in the latter part of his career. Three major strands in his artistic evolution can be identified.[6]

Though Hopper was a painter of landscapes and townscapes, he also painted female nudes throughout his working life. These nudes begin with early studies influenced by Impressionism, include psychologically suggestive and seemingly narrative pictures such as the 1909 *Summer Interior* (p. 8), and culminate in much later works such as *Girlie Show* (1941; compare the study on p. 11) or the 1961 *A Woman in the Sun* (p. 77). These last two are typical of the ambivalent yet vivid portrayals of women that we find in Hopper's late work. Relatively early in his career, Hopper was already approaching his nudes from a characteristic, unmistakably voyeurish stance. *Reclining Nude* (1924–27; p. 9), for instance, implies a situation in which this view of the naked woman has been stolen: she supposes herself unobserved, and has snuggled into a pile of pillows in a spirit of pleasurable, dreamy abandon.

This voyeurish view subsequently became Hopper's preferred perspective on women. In this he was anticipating an approach that Andrew Wyeth and Eric Fischl (among other American artists) were to

Evening Wind, 1921
Etching on paper, 17.5 x 21 cm
Collection of Whitney Museum of American Art, New York, Josephine N. Hopper Bequest
70.1022

adopt in similar fashion.[7] The line initiated by Hopper, a psychological technique that projected unconscious sexual wishes and insights into the coded idiom of visual realism, was continued by the younger artists. And we are inevitably reminded of Hopper when we consider Wyeth's Helga pictures: for almost fifteen years, from 1971 to 1985, Wyeth painted the same woman, over and over again – a secret obsession which the famous painter effectively kept from the public for several years.

Eric Fischl, on the other hand, far more manifestly than Hopper, articulates his fantasies in terms that combine the psychological and historical. The voyeurism in his paintings is not merely the product of private compulsion, not only an analysis of desires repressed by civilization. He is also trying to express the unconscious character of American middle class society. This is something his art has in common with Hopper's, of course: Hopper's accounts of the individual psyche were always accounts of society as well. And what is subversive in Fischl tends to derive from Hopper. Figures presented almost realistically in circumscribed settings are seen in light which has an effect at once defamiliarizing and emphatic. Even when an interior is not specifically marked off from an exterior we are left with a sense of intimacy – even in outdoor scenes (cf. p. 89). To see this effect at work in Hopper we have only to look at his *Moonlight Interior* (1921–23) or the 1928 *Night Windows* (p. 14).

Both Fischl and Hopper show that the male eye treats the female body as a screen onto which to project unconscious desires. They also demonstrate that the male eye sees in ways that have been coded by social and gender norms. But Hopper's pictures of women are obsessive in a different sense as well. Quite plainly he soon reached a point where he was painting only one single woman: his own wife. Jo

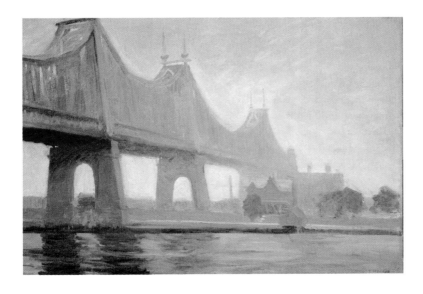

Queensborough Bridge, 1913
Oil on canvas, 64.8 x 95.3 cm
Collection of Whitney Museum of American Art, New York, Josephine N. Hopper Bequest 70.1184

Hopper appears over the decades in a wide variety of poses and situations, in all kinds of roles and at all ages. The effect of this is defamiliarization: what is emphasized is separateness, not common ground. (And we must bear in mind the competitiveness that entered into the marriage of the two artists, a spirit visible in Hopper's cartoons on the subject of married life.)

The second major strand in Hopper's evolution as an artist was initiated by the landscapes characteristic of his transition from an Impressionist (French) period to an early American period. At a very early stage in his career, in addition to pure landscapes (the Monhegan pictures are of particular note) he was also painting compositions in which Nature and Civilization meet – if a confrontation marked by a strict delimitation of spheres can be called a meeting. Time and again, Hopper painted bridges, canals, landing stages and lighthouses. As early as 1909, *The Louvre in a Thunderstorm* (p. 12) showed Hopper marshalling his material in a way that became more important still in his middle and late periods: the natural and manmade worlds, culture and technology, all meet in the picture, and the different spheres are not only defined – they are transformed. The Louvre, emblem of civilization, is seen at a moment of natural menace, and is also practically hidden by tokens of the technological: the bridge and boat. A certain stylistic instability strikes us here, an instability that was to become of increasing importance in the work that lay ahead. The coastline oils done in the decade from 1910 to 1920 use strong colour contrasts and thick paint, but the pictures that juxtapose Nature and Civilization undergo a gradual transition from an Impressionist style to Hopper's more characteristic use of realistic detail.

Soir Bleu, 1914
Oil on canvas, 91.4 x 182.9 cm
Collection of Whitney Museum of American Art, New York, Josephine N. Hopper Bequest 70.1208

"The light was different from anything I had ever known. The shadows were luminous – more reflected light. Even under the bridges there was a certain luminosity."
EDWARD HOPPER

There are nuances and gradations along the line of this transition, needless to say. We might compare the 1909 *Le Quai des Grands Augustins* (p. 13), *Le Pont des Arts* (1907; p. 12) and the somewhat later *Queensborough Bridge* (1913; p. 16). The comparison confirms that Hopper was constantly attempting to re-apply earlier ways of seeing and aesthetic approaches to subsequent compositions. This is strikingly apparent if we compare the 1909 painting *Le Pont Royal* (p. 13) with the famous *House by the Railroad* (p. 30), done in 1925. Other paintings very clearly anticipate later work: *Bridge in Paris* (1906; p. 18), a relatively dark painting with the single colour highlight of a red signal, and *Road in Maine* (1914; p. 19). Both paintings establish and define a sense of civilization which was to become Hopper's central concern.

The third major strand that looks forward to the late work can be seen in Hopper's 1914 painting *Soir Bleu* (p. 17). In part, this picture is the artist's own retrospective on his French, Impressionist-influenced phase. But in addition its psychological coding anticipates work that still lies in the future, and with hindsight we can see it as being linked unconsciously to Hopper's final painting, *Two Come-*

Bridge in Paris, 1906
Oil on wood, 24.4 x 33 cm
Collection of Whitney Museum of American Art, New York, Josephine N. Hopper Bequest
70.1305

Road in Maine, 1914
Oil on canvas, 61 x 73.7 cm
Collection of Whitney Museum of American
Art, New York, Josephine N. Hopper Bequest
70.1201

dians (1965; p. 93). In his last work, Hopper was not only portraying Jo and himself: he was also looking back with melancholy and irony on his own life.

It was no coincidence that *Soir Bleu* was painted the year after the Armory Show, that landmark exhibition that introduced European Modernism and abstract art to North America. In the years that followed the Armory Show, Hopper arguably began to emphasize both his identity as an American artist and the psychological dimension of his art. If we take *Soir Bleu* as initiating a retrospective, then *Queensborough Bridge* unmistakably defines a transition from the European to the American in his art. And we are in a position to grasp the significance of Hopper's critical interest in thoroughly American painters such as John Sloan, Reginald Marsh and Thomas Hart Benton in the 1920s.[8]

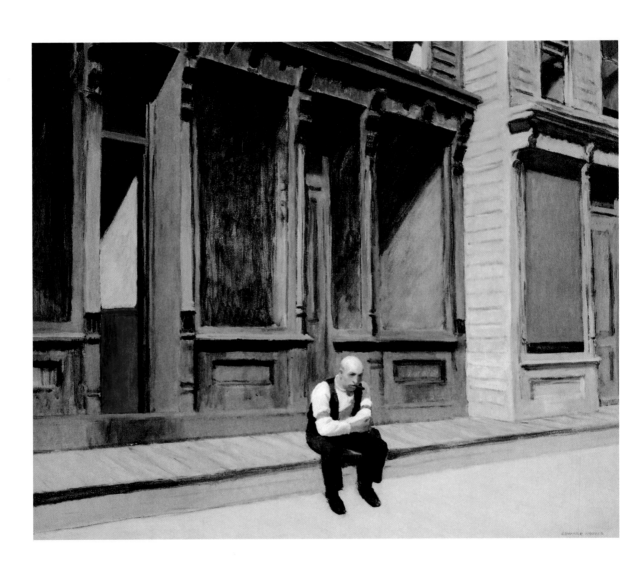

Pictures of the New World

We have already established that certain motifs of Edward Hopper's late work are anticipated in his early paintings, and that this continuity is one reason why the transition from his French to his American art was a gradual one. There was an initial change in the choice of motifs, followed by a profounder change in the artist's technique; but there was no obvious, abrupt hiatus.

The end of Hopper's early phase was marked by paintings such as *Blackhead, Monhegan* (p. 25). His technique in such works was still Impressionist-influenced, but the American natural subject matter introduced a new expressive dynamism into his approach. The distinctions of light and shadow, water and land, are drawn more clearly, and the colours are strong and contrastive, the paint thickly applied. The choice of perspective reinforces this impression of dynamism: our gaze is drawn in at an angle from above, focussed on a coastline, with the crashing waves in the bay only partly visible. The image that results is one of natural forces at odds with each other. The colours are unusual too. The contrast of black shadows and reddish brown earth in the foreground echoes related contrasts based on blue in the upper, skyline portion of the picture.

Hopper was later to perfect the technique of contrast contouring, of over-emphasis of full colour values, and of slight defamiliarization by means of toned-down values. In pictures such as *Cobb's Barns, South Truro* (p. 39), where Nature and Civilization are crassly juxtaposed, Hopper's definition of zones is in fact determined by his use of colour. Later, this process was to acquire a quality of autonomy in his work.

On the other hand, the 1912 *American Village* (p. 22), the first of Hopper's New World scenes, is muted in colour and blurred in contour. True, like *Bridge in Paris* (1906; p. 18) it shows Hopper in the process of abandoning his Impressionist-influenced technique. Two effects breach the overall colour haze: the dark and clearly-defined balustrade in the immediate foreground, and the various bright highlights that puncture the prevailing pastel (the yellow house at left, the yellow streetcar in the upper centre, and the strikingly red chimneys at right and left and in the background). These breaches in the initial overall impression are a carefully calculated effect. They prevent a total view of the scene, and equally prevent us from receiving a unified visual impression.

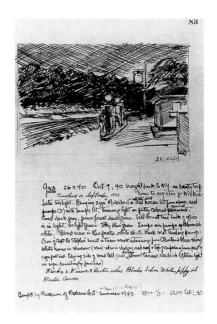

Record Book, volume II, page 83, entry for painting *Gas*, October 1940
Ink and pencil on paper, 30.2 x 18.4 cm
Whitney Museum of American Art, New York, Special Collections, Gift of Lloyd Goodrich

Sunday, 1926
Oil on canvas, 73.6 x 86.3 cm
The Phillips Collection, Washington, D.C.

American Village, 1912
Oil on canvas, 66 x 96.5 cm
Collection of Whitney Museum of American
Art, New York, Josephine N. Hopper Bequest
70.1185

Hopper was already evolving his method of fragmenting his views into a patchwork of differing optical impressions, by perspective and contour means and by striking juxtaposition of colours.

At first sight, the 1914 *Road in Maine* (p. 19) makes a more unified impression. But this appearance is deceptive. Again Hopper is structuring the landscape by means of light and dark contrasts and by using idiosyncratic colour values; the perspective he has adopted also contributes to the painting's dynamics. Viewing the scene at an angle, from a slight elevation, we see only a small section of the road (which is following the lie of the land) and cannot see where it continues. Since there are no telegraph wires to be made out between the poles, and the next pole (which must presumably be somewhere in the foreground) is not in our line of vision, the perspective is subtly subverted. This picture of a country road is plainly "about" the limits Nature and Civilization impose on each other. In terms of perspective we might compare the later (1941) painting *Route 6, Eastham*, where the same theme is treated even more directly.

In fact, the use of images from modern technology becomes a strik-

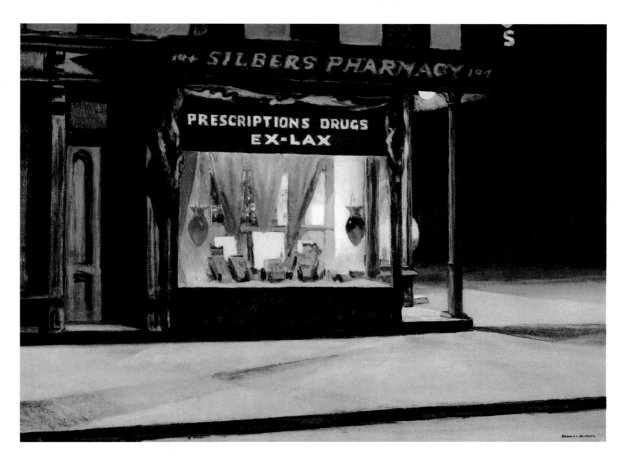

PRESCRIPTIONS DRUGS
EX-LAX

Drug Store, 1927
Oil on canvas, 73.7 x 101.6 cm
Courtesy of Museum of Fine Arts, Boston,
Bequest of John T. Spaulding

ing constant in Hopper's New World pictures. Cars and railroads are
of prime significance in his work. Of course he rings the changes. In
Route 6, Eastham his perspective is the calm, steady view from a
parking car, whereas in *New York, New Haven and Hartford* (p. 24)
we are afforded only a fleeting glimpse of a railroad landscape, such
as we might see when we look out of a train window. In this picture,
Hopper destabilizes perspective and introduces movement within the
same work. Although the track in the foreground is almost parallel to
the bottom edge of the painting, and although we are looking full on
at the houses (at what is nearly a right angle), we still cannot deter-
mine the direction of the movement from which this landscape seg-
ment has been registered. In this fleeting glimpse, Nature and Civiliza-
tion have been conflated. It is a viewpoint that acquires increasing
significance in Hopper's later work.

The compositional arrangements were supposedly dictated by
chance. But Hopper was evolving a system of signs designed to char-
acterize the nature of individual experience in the New World. It was
a system that produced pictures very different in compositional char-

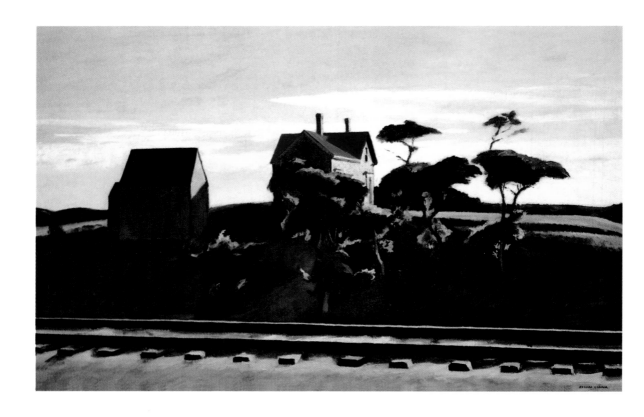

New York, New Haven and Hartford, 1931
Oil on canvas, 81.3 x 127 cm
Indianapolis Museum of Art, Emma Harter
Sweetser Collection

acter, of course: Hopper did not restrict himself to a set iconography, but instead applied his method to different kinds of situation.

Sunday (1926; p. 20) is an early example of this. It is a painting that quite unmistakably redeploys the iconography in other works by the artist. In it, Man (representing the natural order) appears small, reduced in importance, a chance feature of a suburban scene. The man in the picture is not gazing out at a busy street scene; rather, he seems lost in his own thoughts, excluded from the realm of Civilization and without access to Nature. His unseeing stare eerily echoes the sightless gaze of the apparently empty store windows. The town makes a deserted, dead impression and it is hard to say whether anything at all is actually sold in the store.

However symbolic Civilization's icons may appear in Hopper's paintings, however much they may be part of a system of signs, we must add that they are still plainly there because the artist took a simple, even naive pleasure in them as everyday things. It is a pleasure we see in *Drug Store* (1927; p. 23), and later in *The Circle Theater* (1936), *Gas* (1940; pp. 26–27) and *El Palacio* (1946; p. 29). All four pictures make conspicuous use of lettering. We see brand names such as Mobilgas or Ford. And occasionally Hopper indulges in a little irony when he highlights this lettering. For instance: in the

painting of the venerable corner drug store, Silber's Pharmacy, the crass advertisement for "Ex-Lax" (a laxative to ease one of Civilization's endemic ailments) contrasts not only with the store name in terms of its lettering style but also with the old-fashioned dignity of the window display of jars, drapes and gift sets. In *The Circle Theater*, the theatre ads are almost hidden by the subway entrance, and advertisements for ice cream, candy, drugs and soda dominate the foreground.

This series also provides a record of Hopper's characteristic ambivalence. On the one hand, his love of detail seems a throwback to verism and an anticipation of the photo-realism of painters such as Richard Estes. On the other hand, even here Hopper is defamiliarizing his subjects. The drug store, brightly lit up from within, is in a dark street and lights up only a portion of it. The window points up the emptiness of this system of signs: there is no one to read the message. In *The Circle Theater* a human figure, small and lost, is almost completely swallowed up by the colour contrasts of the buildings. The petrol station in *Gas* is like an outpost marking the frontier of Civilization as it takes its stand against Nature. Both the colour contrasts and the compositional structure serve to emphasize this tension; and when we look at the picture we find that our gaze probably moves from the roadside to the petrol station and the lettering, Mobilgas. *El Palacio* uses perspective shifts to similar effect. On the one hand, the hotel logo is merely one sign among many; on the other hand, of course, we are seeing it not from the street (from which access to the hotel would presumably be possible) but across the rooftops and housefront cornices of a town whose barred windows and balcony ironwork sug-

PAGE 26/27:
Gas, 1940
Oil on canvas, 66.7 x 102.2 cm
Collection, The Museum of Modern Art, New York, Mrs. Simon Guggenheim Fund

Blackhead, Monhegan, 1916–19
Oil on wood, 24.1 x 33 cm
Collection of Whitney Museum of American Art, New York, Josephine N. Hopper Bequest
70.1317

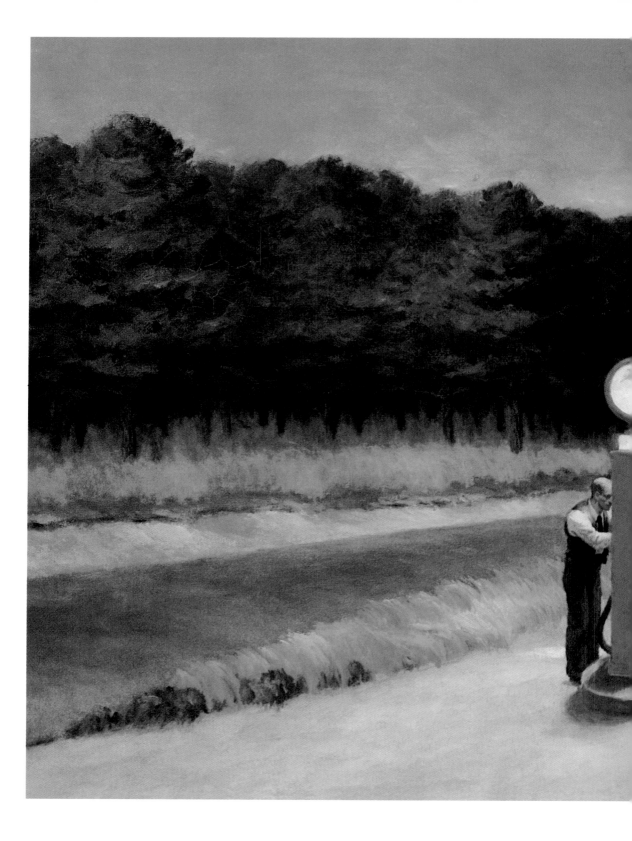

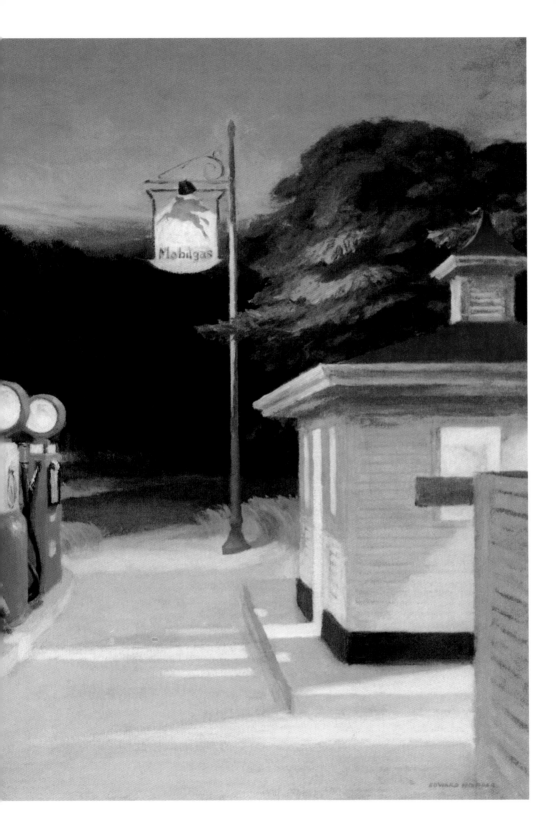

gest a location in Mexico. The contrast between the name "Palacio" and the flat roofs, dreary façades and (apparently) a water tower is palpably ironic. In the tangle of urban life, the only points that provide any orientation are advertising logos.

These paintings do not aim at psychological effects, and are not especially accessible to symbolic interpretation either. Rather, they focus steadily on the signs themselves. In these works, Hopper is reconstructing an uncomplicated and unprejudiced pleasure in the signs of Civilization. It is a pleasure we find equally in Americans who set out to record the everyday facts of their own country (Raymond Carver, Thomas McGuane) and in Europeans who discover the fascination of the continent (Peter Handke, Wim Wenders). In making these signs his subject, Hopper was adopting a technique that partially took him beyond Modernism. First the principle of classical, mimetic representation had reigned supreme; then, in the Modernist heyday, it had been superseded by the triumph of abstraction. Hopper's art rediscovered what lay on the surface. And indeed, it is an art that often resists psychological or symbolic decoding. A surface is a surface is a surface: the signs mean nothing beyond themselves.

This was a development that occurred only gradually in Hopper's work. Behind it lay the archetypes of the New World, of the confrontation of Nature and Civilization. Hopper discussed this subject in a 1928 article on the art of Charles Burchfield. In it, he related the American line in painting to European aesthetics. Hopper took his bearings from the 19th century American philosopher-poet Ralph Waldo Emerson and also from a quotation from Goethe: "The beginning and end of all literary activity is the reproduction of the world that surrounds me by means of the world that is in me. But Hopper also – and in this respect, in spite of their many differences, he proves to be Burchfield's kindred spirit – felt that this reproduction must proceed from transformation. What he admired in Burchfield was that, however complex the experiential world, he still adopted simple methods of painting. [10]

He found Burchfield's technique astonishing, so simple and natural in those highly sophisticated times, and urged that an intelligent and aware artist should not go along with the intellectual deviations of his contemporaries if he possessed a sure sense, an original view and doggedness. He considered the task of art to be to reflect upon itself and to aim for independence in the future. [11]

In the same essay, Hopper made observations which explain his subsequent preoccupation with elementary denominators of Civilization, particularly architecture, houses, and the position of houses in relation to natural environments. He drew attention to the distinctive sign system inhabited by American architecture, which combined a wide, heterogeneous variety of styles in an early, naive anticipation of postmodern plurality in architecture. In Hopper's eyes, American

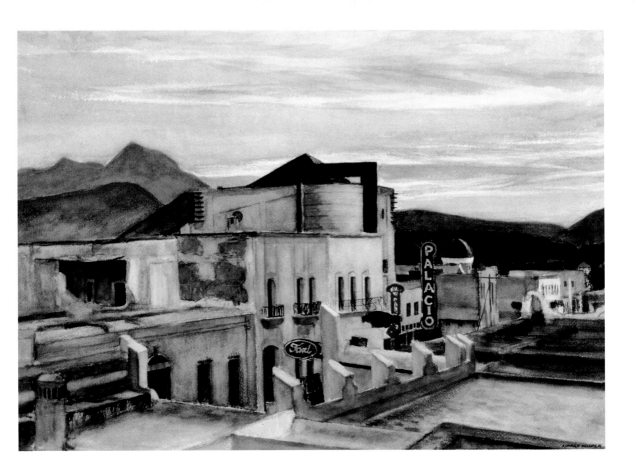

architecture made demands on realist painting that were of a thoroughly contemporary nature; he wrote how the natural lethargy and vanity of human nature had induced artists, from primitive painters to the post-impressionists, to use that material which the original artist had brought to life.[12]

Thus Hopper's article on Burchfield not only provides an explanation of his choice of subjects but also accounts for his smooth transition from a mimetic art (supposedly no more than realistic, representational and tending towards the narrative) to a symbolic art. For the self-reflexive sign system established in his paintings not only recodes realistic elements and symbolic relations; it also creates a new context – a second surface. This makes for an impression that cannot be put into words and is scarcely accessible to graphic art either. To Hopper's way of thinking, all painting was subject to this law of transformation. For him there was no clear distance in this context; the object had been seen, time had stood still and one experienced again the excitement now spiritually processed into parallels of art.[13]

El Palacio, 1946
Watercolour on paper, 52.7 x 72.7 cm
Collection of Whitney Museum of American
Art, New York, Exchange 50.2

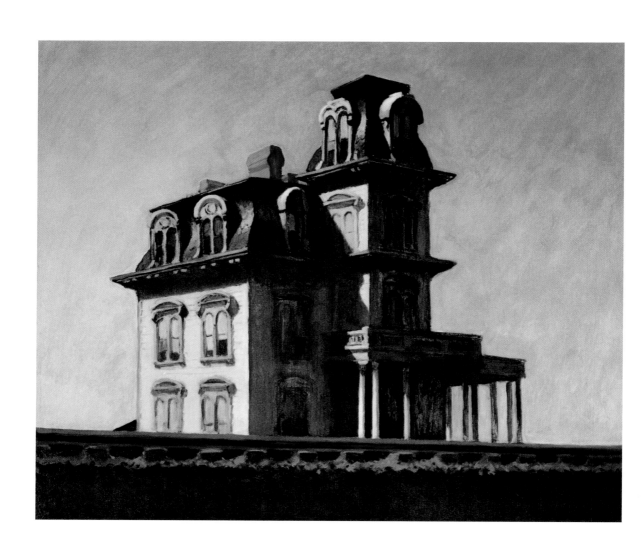

The Frontier of Civilization

Edward Hopper's work became increasingly ambivalent, indeed ambiguous in tone. This ambiguity derived from an attempt (inspired by Emerson) to express an inner truth of perception, on the one hand; and, on the other, from the artist's development of a self-reflexive system of signs. When the Museum of Modern Art in New York presented a first major retrospective of Hopper's work in 1933, Charles Burchfield wrote: "Some have read an ironic bias in some of his paintings; but I believe this is caused by the coincidence of his coming to the fore at a time when, in our literature, the American small towns and cities were being lampooned so viciously; so that almost any straightforward and honest representation of the American scene was thought of necessity to be satirical. But Hopper does not insist upon what the beholder shall feel. It is this unbiased and dispassionate outlook, with its complete freedom from sentimental interest or contemporary foible, that will give his work the chance of being remembered beyond our time."[14]

In this view, Burchfield was implicitly recognising that Hopper considered the dichotomy of mind and nature (which Emerson had sought to reconcile) as a permanent conflict. In drawing upon the epistemology of Emerson and H. D. Thoreau, the American Transcendentalists, Hopper was not closing off the scope of perception; he was including a sense of fundamental fracture in his work. And in the art he created in the middle and late periods, that sense was not only psychologically encoded, but also frequently rendered in perfectly literal visual terms.[15]

Railroad Crossing (1922/23; p. 33) is a good example. Together with other Hopper landscapes, it shows the artist adopting the formal repertoire of Modernism. Unlike 19th century American landscape artists such as Frederic Edwin Church or Thomas Cole, Hopper was not panoramic in his approach. Vast natural prospects such as that in Cole's *The Oxbow* were not for him. The Hudson River School had painted in a style derived from the European classical landscape tradition (while often adapting it to their own expressive ends); Hopper's landscapes, by contrast, made idiosyncratic use of perspective, and allowed natural features or signs of Civilization to mark his boundaries.

It was a way of seeing that later became typical of the perception of things technological. For Hopper, it became fundamental at an early stage in his career. If we look again at the early (1913) *Queensbo-*

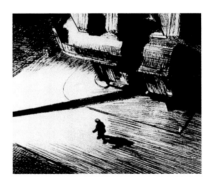

rough Bridge (p. 16), we see that it is not only a continuation of a specifically French tradition. It is also conceived as an alternative to Futurism. There was a large-scale Futurist exhibition at the Bernheim Jeune gallery in Paris that year; and 1913 was also the year when the famous Futurist-influenced *Nude Descending a Staircase*, by the French Dadaist Marcel Duchamp, alarmed visitors to the Armory Show in New York. Futurism aimed at a revitalization of art, and of life, by means of technology. Hopper felt sceptical about this, and in place of Futurist hubris he offered his perspectival scenes including cars, trains and roads – a straightforward record of technical progress. For the Futurists, there was no limit to what mankind could accomplish; for Hopper, the imposition of limits became the characteristic strategy of a realistic art.

Here once again we can take *Railroad Crossing* as an example. The woodland and fields on the one hand, and the house, signals, telegraph poles and railway track on the other, show two opposed systems (the natural and the technological) meeting and establishing a mutual demarcation. We see this process at work time and again in Hopper's art. Sometimes it appears in trivial, anecdotal form, as in the 1923 etched version of *Railroad Crossing*, which shows a man waiting with a cow at a closed crossing, the two figures framed by a telegraph pole and a large stop sign. Another etching, *American Landscape* (p. 32), treats the same motif in emblematic style: in this view the track cuts across the picture horizontally, and a herd of cattle are about to cross it, moving from the pasture (Nature's territory) to the realm of Civilization (denoted by the house).

These etchings use emblematic, narrative elements to highlight particular statements. There is a 1926 watercolour version of the *Railroad Crossing* that curiously understates the same insights, though

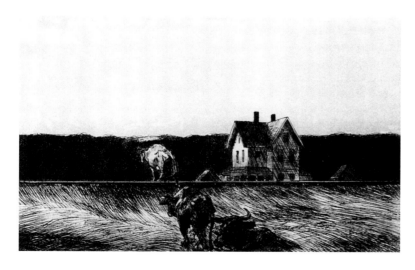

American Landscape, 1920
Etching, 20 x 25.1 cm
Philadelphia Museum of Art,
Purchased: Harrison Fund

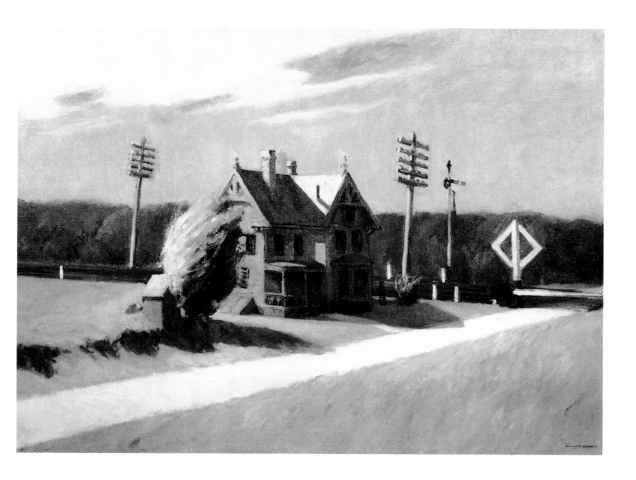

they are still clearly articulated. It too confronts Nature and Civilization by showing the incursions of the latter into the natural world: we see a railway crossing once again, and the path that leads into Civilization's domain rises up an incline beyond the track, hiding the base of the house from sight. Hopper had of course anticipated this effect in the oil *Railroad Crossing* (p. 33), by using an unusual perspective and by making the track and signs demark the boundary separating domesticated Nature (near the house) from its dark and untamed equivalent, the brooding pathless woods beyond.

At this point it was already clear that houses had central importance in Hopper's art. Like the railroad signs, they are of course emblems of Civilization; but at the same time they remind us that Civilization depends upon the laying down of boundaries. And Hopper goes further: often, his houses show that the resulting separation is permanent, and mankind is now debarred from Nature.

House by the Railroad (1925; p. 30) exemplifies this in various respects. The house was most probably built earlier than the railway; at

Railroad Crossing, c. 1922–23
Oil on canvas, 73.7 x 101 cm
Collection of Whitney Museum of American Art, New York, Josephine N. Hopper Bequest 70.1189

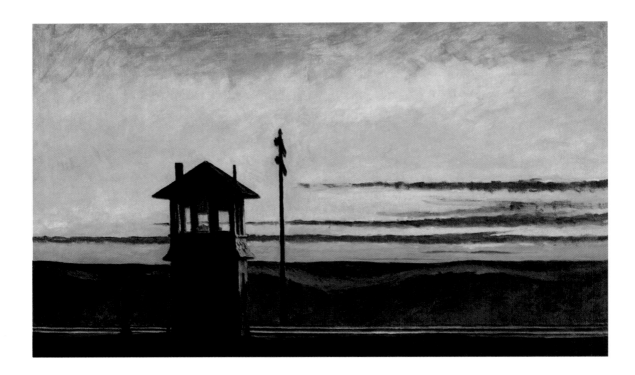

Railroad Sunset, 1929
Oil on canvas, 71.8 x 121.3 cm
Collection of Whitney Museum of
American Art, New York,
Josephine N. Hopper Bequest 70.1170

least, its architecture is reminiscent of a pre-industrial age. The house also seems lost, and out of place, in the location we see it in. It is a detached house in an open, treeless area – the sole relic of a ghost town forgotten by history, as it were. The turret, eaved frontage and verandah were doubtless originally conceived for leisurely contemplation of Nature; but now the railway runs right past the front of the house. The track itself contributes to the forlorn impression: it not only cuts horizontally across the picture again, concealing the base of the house from our view, but also seems itself a part of ravaged Nature. The browns of the rusty track and the permanent way contrast robustly with the pallid bluish-grey of the house (though it does have the russet chimneys we repeatedly see on Hopper's houses). It may not be going too far to see in the warm brick-red of the chimneys a token of the life that once warmed the house, now so forlorn. The desolate impression is of course heightened by the blind windows, some of them open, most of them closed. Some of the windows reflect the light, and (characteristically for Hopper) none of them permit us to see inside. To emphasize the prevailing melancholy, Hopper has also painted the sky (which covers a large proportion of the canvas) in a pale, expressionless whitish-grey. Though the shadows suggest that the sun is quite high, there is little blue in the sky; there are also no cloud formations. It is a striking proof of Hopper's ability to establish total emptiness in heaven and earth alike.

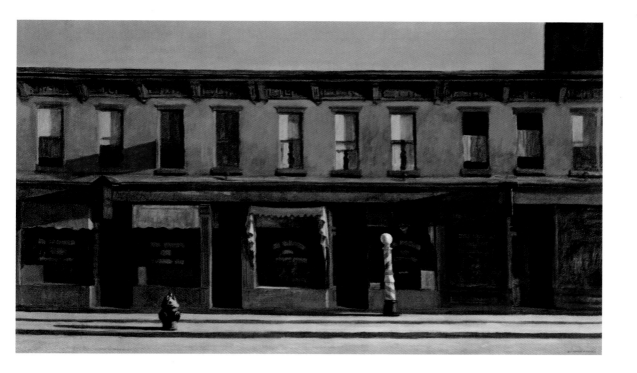

The contrast with the 1929 *Railroad Sunset* (p. 34) is dramatic. The later picture, an eloquent sunset scene in New England, is in expressive colours, and the composition reverses the approach in *House by the Railroad*. Now we are not looking at Civilization, but out of it and towards a realm of apparently unspoilt Nature. True, the railway track still marks the divide. But the natural scene beyond it seems to be promising new life, and makes a welcoming impression. Hopper's use of light effects emphasizes this sense: the track is glistening in the light of the setting sun, and the dusk has produced a wavy green contour along the crest of the hills. In this painting, Hopper's use of colour and light show that, however much he was trying to reproduce natural phenomena realistically, his method was in fact fundamentally influenced by Modernist approaches to art: his colour effects do not depend on representational functions, and his colour values acquire an autonomous character within a patterned scheme. In *Railroad Sunset* the subject, structure and colour values establish a twofold aesthetic system: representational and semi-abstracted.

Something similar can be seen in a painting Hopper did the following year, *Early Sunday Morning* (p. 35). Not that there is any obvious relation between this picture and *Railroad Sunset*. Yet Hopper seems to be trying to apply the colour system of the natural scene to a city street; the two works seem to correspond in palette, and furthermore in motifs. *Early Sunday Morning* uses a divide once again; here the

Early Sunday Morning, 1930
Oil on canvas, 88.9 x 152.4 cm
Collection of Whitney Museum of American Art, New York, Purchase with funds from Gertrude Vanderbilt Whitney 31.426

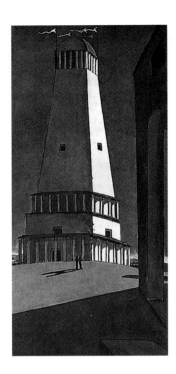

Giorgio de Chirico
La nostalgia dell' infinito, 1913–14
Oil on canvas, 135.2 x 64.8 cm
Collection, The Museum of Modern
Art, New York

PAGE 37 TOP:
Lighthouse Hill, 1927
Oil on canvas, 71.8 x 100.3 cm
Dallas Museum of Art, Gift of Mr.
and Mrs. Maurice Purnell

PAGE 37 BOTTOM:
Coast Guard Station, 1927
Oil on canvas, 73.7 x 109.2 cm
Collection The Montclair Art
Museum, Montclair, New Jersey

street is the boundary, and we are looking across it to the houses on
the other side. The façades pick up the reds, greens and yellows of
Railroad Sunset; and, as if to establish a kind of symmetry between
the two paintings, Hopper has introduced a striking vertical (the bar-
ber-shop candy-stripe pole) into the right-hand side of the later work,
to match the signal and signal-box in the left of the railway scene.
Whereas the earlier picture emphasized flowing landscape contours,
though, the dominant shapes in *Early Sunday Morning* are manmade
and geometrical.

The 1930 work highlights a tendency that was already apparent in
Railroad Sunset: to render the dichotomy of the animate and the inani-
mate in a play of light and shadow, using forms essentially rectilinear
or geometrical. Hopper has ironically included within the picture a
telltale sign that this construction is a purely artificial affair devised
by the artist: at right, the colourful façades that dominate the picture
are dwarfed by a towering dark building, thus reminding us that the
view presented by the painter is a deliberately selected and cropped
sub-part of the available architectural scene. This is a reminder that re-
curs in other pictures Hopper painted of houses, level crossings and
towers. Again and again he signals that the chosen view is merely part
of a larger whole.

The technique was a thoroughly deliberate strategy, as another
example will show. In 1927 Hopper painted the famous *Lighthouse
Hill* (p. 37), and parallel to it did two watercolours in the same year,
the first showing only the base of the lighthouse, the second showing
it almost entire but cropped of its tip. This concentration on partial
views is related to the oil *Lighthouse Hill* which offers a boundary be-
yond which we can see nothing. The spatial boundary expressed a his-
torical turning-point: the west tower of the Cape Elizabeth lighthouse
station (near Portland, Maine) was due for dismantling, in spite of
seamen's protests. In painting this symbol of a frontier, Hopper was
also keeping the memory of 19th century seafaring fresh. The picture
shares the ambivalent quality of *Early Sunday Morning* in that it not
only presents a tranquil scene but also provides a commentary on the
Depression of the 1930s.[16]

Despite Hopper's later assertion that *Early Sunday Morning* was
"almost a literal translation of Seventh Avenue"[17], the picture has
quite obviously been subjected to his characteristic twofold encoding
(and, in any case, the façades seem to have been modelled on some re-
membered theatre set). The fact that Hopper originally intended to
paint a human figure at a first floor window and then decided against
having any human presence in the painting points up the importance
he attached to architecture. These 19th century shopfronts and build-
ings plainly highlight a social conflict: the conflict between the Ameri-
can individualist ideal, an ideal typically expressed in financial self-
sufficiency and independence, and the encroachments of corporate

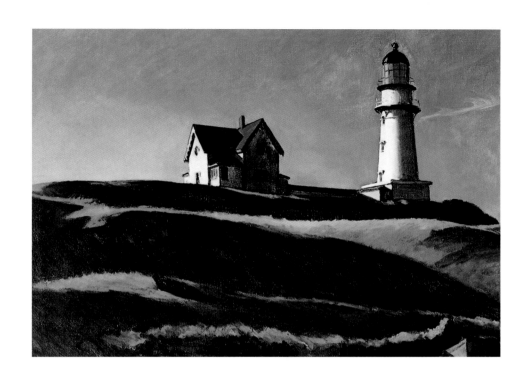

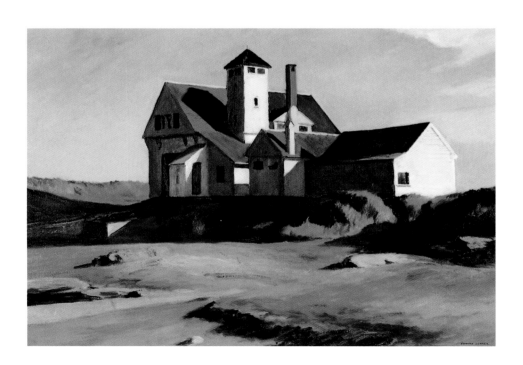

industry. What Hopper was adumbrating in this painting became a stereotyped view in later works – but it also acquired a more precise focus: Hopper increasingly tended to portray people in specific social milieux.

For all their affinities in the late 1920s social background, the city scene and the lighthouse painting make a radically different impact, though. *Lighthouse Hill* is an infinitely more expressive accomplishment, thanks to the angle Hopper chooses, his colours, and his use of light and shadow. We see the lighthouse from below, and the hilly landscape in the fore and middle ground is undulating and not unlike waves at sea. The crests of these waves are sunlit, but the depressions are so dark that the proportions and depths are not immediately apparent. It seems possible to walk to the lighthouse across these downs; but we know that where the picture is cropped at right the cliffs fall sheer to the sea.

Hopper's use of light and shadow on the architecture and natural landscape not only establishes distinct contours and demarcations. His effects also defamiliarize what we see, endowing what looks at first glance so realistic with the qualities we associate with the metaphysical art of painters such as Giorgio de Chirico. The shadow that divides the lighthouse vertically is reminiscent of a similar play of light and dark (also on a tower) in de Chirico's *Nostalgia dell'infinito* (p. 36). In the Italian's painting, too, the chosen angle seems to confront us with a sectional view as if by chance. De Chirico too uses a foreground line to mark the ground. And where the top of de Chirico's tower stands out in bright red against the sky, Hopper's lighthouse tip seems curiously to shed a pink pallor into the rich blue of his Maine sky.

In its structure, colour scheme, and use of light and shadow, *Light-*

Solitude, 1944
Oil on canvas, 81.3 x 127 cm
Private collection

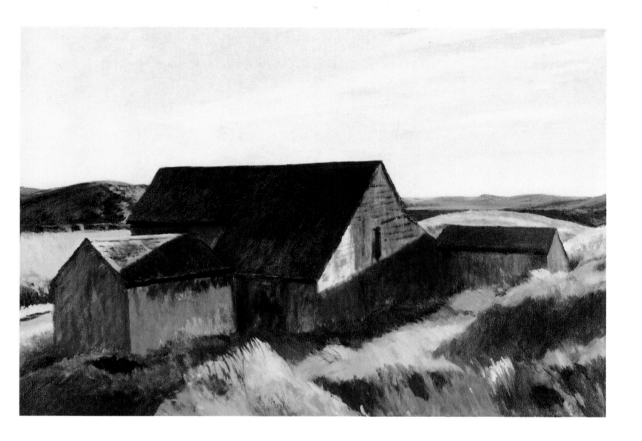

house Hill is clearly a transitional work. Hopper subsequently made greater use of the interplay of light and shadow, and of colour highlights, in order to present his houses and other buildings not merely as the frontier signs of Civilization but as essentially ambivalent in themselves. *Coast Guard Station* (1927; p. 37) is a good example of this. The picture uses the same compositional strategy as *Lighthouse Hill*, and the defamiliarization effected by the deployment of light and shadow is if anything even greater. The coast guard station also shares the forlorn character of the *House by the Railroad* – it too is surrounded by intractable, indifferent Nature. We are looking at the station from what is apparently the seaward side (marked by the tower). There are no paths in this terrain, and even the approach to the station itself is difficult to make out. The building seems at the mercy of invisible forces, in the grasp of a stark chiaroscuro.

The tension we sense in the painting as a whole is summed up in the twin verticals of the white lookout tower and red chimney, placed almost exactly in the centre of the picture. The textural light and shadow contribute an expressive dynamism to the work and defamiliarize the impression too; and this effect is reinforced by the strongly contrasting whites, reds and blacks. The result is that the coast guard sta-

Cobb's Barns, South Truro, 1930–33
Oil on canvas, 86.4 x 126.4 cm
Collection of Whitney Museum of American Art, New York, Josephine N. Hopper Bequest 70.1207

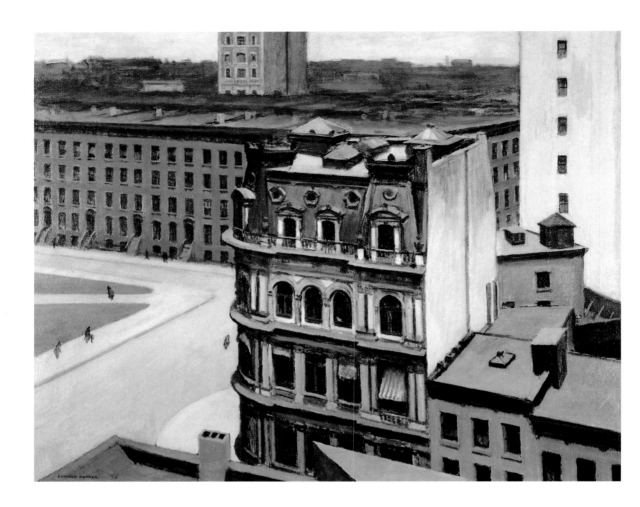

The City, 1927
Oil on canvas, 70 x 94 cm
University of Arizona Museum of Art, Tucson,
Gift of C. Leonard Pfeiffer

tion seems as alien in its natural setting as (say) Cobb's Barns do in
the somewhat later rendering of a rather different building in the
South Truro landscape of Cape Cod.

In the early 1930s, Hopper rented Burly Cobb's house at South
Truro, and subsequently built himself a house there.

In *Cobb's Barns, South Truro* (p. 39) he uses the play of light and
shadow to such effect that the divide that marks off the grassland
from the buildings is almost erased. This impression is strengthened
by the colour consonances that link the buildings with Nature: the cop-
per and russet tones of the barns recur in the fields and hills. The idea
basic to the painting is not unlike that in *Coast Guard Station*, but the
effect is in fact different. Hopper is not tracing the demarcation line
between Civilization and Nature but is instead showing Civilization in
the process of returning to Nature. In fact Hopper was again respond-
ing to the historical moment: in this case, the impact of the Depres-
sion on farming, which resulted in colossal rural depopulation in the

late 1920s. Vast tracts of arable land were reclaimed by Nature. Bearing this in mind, we see that Hopper's painting of the barns has an added, poignantly critical point. But although he had actual social conditions in mind, we may still encounter problems in interpreting the picture, because *Cobb's Barns* too has been processed through Hopper's dual coding: the detailed registration of the actual, with its arguably implied social critique, has been overlaid with an expressive texture of shapes and colours.

By the end of the 1920s, Hopper's pictures of houses, landscapes and city scenes had already acquired an emblematic function, standing for the conditions of human life. A painting done in 1927, *The City* (p. 40), is characteristic in this respect. To an extent it is a self-quotation, alluding to earlier drawings such as the 1921 *Night Shadows* (p. 31), in which Hopper had used dramatic perspective and diagonals to establish an unusual compositional structure that reminds us of his debt to Edgar Degas. The dramatic impact of *Night Shadows* derives from the angle at which we see the nighttime walker, his shadow, and the tree's shadow. This last is not only outsize; it also intersects the right angle of the street corner almost precisely in the middle, as if the composition were a geometrical exercise. Central perspective is subverted. The tree's shadow cuts across an almost white area at the left of the picture. It is a dynamic composition, and it generates an unmistakable sense of menace, as if the man's walking route (which is taking him into the brightly-lit area) were taking him beyond a divide and into a danger zone. We might compare *New York Pavements* (1924), which shows a nun pushing a pram, her wimple blown back by the breeze.

The City is similarly expressive. The façades and streets are similarly geometrical in layout. The path intersects the lawn at left in similar fashion (like the shadow intersecting the pool of light). Apart from a single striped awning, the windows of the houses are blind and vacant. The figures in the street constitute a vestigial human presence. There is little more to be said about them, except that they seem to be leaning into the wind as they walk. If we look again, we see that they all appear to be leaning in different directions. Calm as the composition seems as a whole, the tranquillity is ruffled in an unsettling way by this curious inconsistency.

The two pictures show that, even where human figures were absent, or present as mere ciphers, Hopper was using his views of houses and cities to suggest the forces that govern modern life. This line in his art was continued as late as 1942 in *Dawn in Pennsylvania*, where we see an area (divided by railway tracks) that is not only deserted but indeed seems positively hostile. Two other paintings done in the 1940s, *Solitude* (1944; p. 38) and *Two Puritans* (1945), are related. The wayside house in *Solitude* by a road that disappears to the horizon, seems an alien intrusion in the landscape, thanks to the

strong colours and the position. There is no track from the house to the road: indeed, the house appears to have opted deliberately for seclusion among the trees. The right-hand side of the composition offers a natural environment encompassing the house, while the left is so different in character that it could almost be part of an entirely different work.

Two Puritans adopts the same strategy. Both pictures, unlike *House by the Railroad* (where the divide is dictated by chance), conjure up a sense of deliberate exclusion. The house in *Solitude* is marked off from Civilization by the woods it is set in, and in *Two Puritans* we see two houses that are not only divided off by tree-trunks in the foreground but are also separated from each other by white fencing. With ample irony, these verticals function as phallic symbols, and so counterpoint the implications of the title.

Both paintings introduce a psychologizing and dramatic element to the demarcation of interiors and exteriors; and the tendency becomes even more pronounced in Hopper's 1945 painting *Rooms for Tourists* (p. 43). It is an ambivalent, Freudian world in which the things that comfort us and the things we find unsettling are implicitly shown to have the same origins. The house defies the night, offering comfort and (in every sense) accommodation. The lighted rooms and the sign by the hedge promise security. Nonetheless, Hopper places a question mark over the comfort and the security, so to speak: there is nobody to be seen in the house, and the very light has a mysterious quality, as if it all derived from a single source that irradiated through the house. The painting transcends realism. The house perhaps recalls the strangely lit-up house in Munch's *Stormy Night* (cf. p. 42). It is worth noticing that the house is the only thing in Hopper's painting that is lit from some (unidentified) source beyond. The two light sources, within and without, meet at the front of the house. The quirky, defamiliarizing effect of the light might be compared with that in René Magritte's *L'Empire des Lumières II* (p. 90).

The double light source, which gives this painting its distinctive overall impact, encodes the content of the picture in a twofold way. In his use of this device, Hopper strayed ever further from the fold of realism. His pictures articulate unconscious fantasies, and resist interpretation purely in terms of symbolism or iconography. In place of narrative or representation they use images which do not merely convey a descriptive account of some external reality but in fact become self-referential by closing the gap between image and referent.

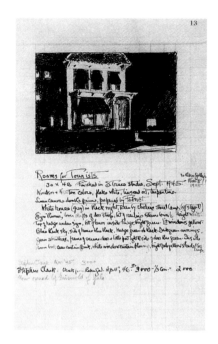

Record Book, volume III, page 13, entry for painting *Rooms for Tourists,* September 1945
Ink and pencil on paper, 30.2 x 18.4 cm
Whitney Museum of American Art, New York,
Special Collection, The Museum of Modern Art

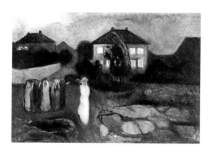

Edvard Munch
Stormy Night, 1893
Stormen
Oil on canvas, 91.5 x 131 cm
Collection, The Museum of Modern Art,
New York

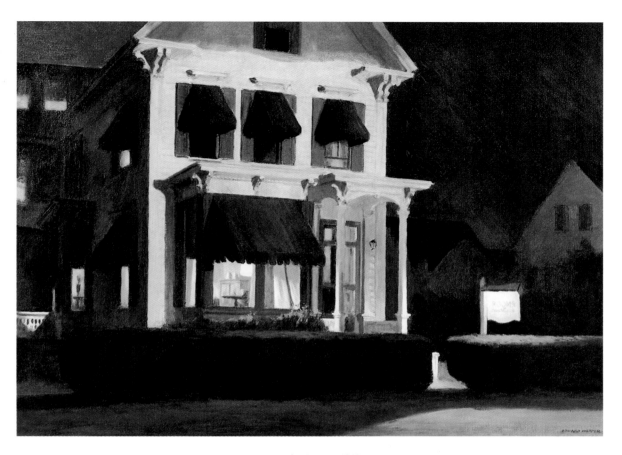

Rooms for Tourists, 1945
Oil on canvas, 76.8 x 107 cm
Yale University Art Gallery, New Haven,
Connecticut, Bequest of Stephen Carlton Clark,
B.A. 1903

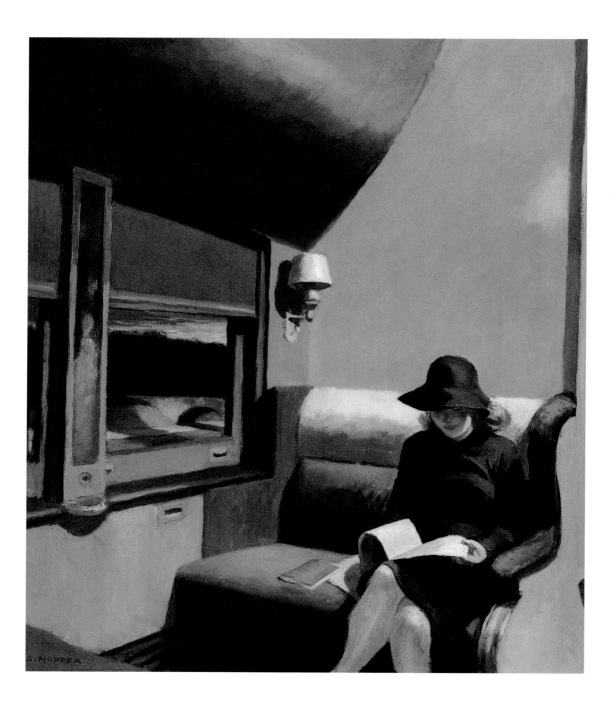

Man and Nature

The pictures of the 1940s that can be traced to earlier sketches and ideas show that Hopper's cityscapes, and the paintings in which he expressed the conflict of Nature and human Civilization, always included experience that can be analyzed in psychological terms. The tokens of the two realms that appear in his work are interchangeable; but, more than that, the effect of the two sets of signs taken together is often of a single, unified set. This being the case, the paintings in which Hopper guides our view from the realm of Nature into the realm of Civilization could often just as well be reversed: the two realms are finally the two halves of a symmetrical design.

We can see this interchangeability at work in *Compartment C* (p. 44), which the artist painted in 1938. The picture both uses and defamiliarizes earlier approaches. Through the train window we see a landscape the features of which (a river, bridge and dark woods) restate the familiar dichotomy. And the picture also has its own distinctive energy, owing to the slant angle at which we view the scene.

The picture's focus on one corner of the compartment produces a dual effect. The compartment where the solitary traveller sits reading seems oddly bigger than it actually can be: it is as if she were sitting in a plush armchair in a spacious home. And the train chassis seems to be warping away from us – as a result of which, the landscape seen through the window has a two-dimensional look, like a picture of a landscape: it might as well be inside as out. The view through the window suggests both a divorce from the natural world and a metamorphic process affecting the immediacy of perception. The fact that the woman is reading is symbolic of isolation; she is closed off within herself, her attention on a system of signs different from that of direct representation. It is true that the isolation in *Compartment C* is understated. This, if anything, heightens the ambiguity of the mood. The use of colour, rather than creating a caesura to separate interior from exterior, has the effect of establishing points of reference. The woman's absorption is relaxed, though she is concentrating too.

The 1939 *New York Movie* (p. 48) offers a parallel to this picture. This time a cinema screen occupies the place of the view from the train window; it seems the film is set in an Alpine landscape. The glimpse we have of the movie only accounts for a small part of the picture, though. In fact, that portion of the canvas is dwarfed by the monumentality of the interior, with its proscenium, its ornate ceiling and lighting, the columns and drapes, the passage and stairs. It is an

"In Hopper's work the window (as eye, as vacancy, as threshold, as silence, as labyrinth, as escape) is a common denominator to the illusive transaction of the pursuer, pursued, and witness, which, I believe, have hardly begun to be understood. [. . .] Instead, he achieved a neutrality that made his pictures available to numerous readings, depending on the observer's capacities." BRIAN O'DOHERTY

Compartment C, Car 193, 1938
Oil on canvas, 50.8 x 45.7 cm
Collection IBM Corporation, Armonk, New York

energized interior; the very dynamism of its design is a stark contrast to the torpor of the usherette at right. The usherette seems as absorbed in a world of her own as the woman reading in *Compartment C*. Her isolation is reinforced by the perspective of the composition, which directs our attention firstly to the wall that divides the cinema auditorium from the exit, and then to the fact that from where she is standing the usherette cannot see the screen: this, we conclude, is a woman who (judging by her indifference) has no need of the illusions and escapism that cinema affords.

Hopper developed the idea in a much later work painted in 1963: *Intermission* (p. 61). But the later picture is different. In *Compartment C* and *New York Movie* his subject was the solitary absorption of women in isolated situations, situations that also suggest a certain security and snug protection; but in *Intermission* it is as if the motif has been turned inside out. The woman is alone in the auditorium, a bare setting consisting of seating, emergency exit, and a fragment of the proscenium. It is she herself who conveys the desolate sense of desertion. The dominant colour is the arctic blue of the wall, and the only warmth comes from the seats, floor and stage. The effect is to emphasize the absence of pleasure – it is, after all, the intermission, and the woman is not watching anything.

The 1957 *Western Motel* (p. 47) is comparable in its choice of motif. Again Hopper uses a defamiliarized view outside: through the outsize motel windows we see what looks like the archetypal Western movie setting. But the woman sitting on the bed is not gazing at the view; she is turned towards us, and the overall effect is of a portrait sitter seen against a landscape frozen into a mere background. Once we have noticed this, we should not overlook the sense of movement that counterbalances the inertia. It is true that the car and the street (and the suitcase, suggestive of departure or arrival) somehow seem robbed of their dynamics by the frozen look of the woman. However, the light seems to restore energy to the situation – even as it freezes the exterior into the semblance of a movie set. The effect of the view through the windows is not unlike that of the landscape glimpsed outside the train in *Compartment C* or the cinema screen in *New York Movie*.

The energy and inertia that conflict so fraughtly in this painting are of course psychological in nature too. The hood of the automobile parked outside makes a phallic impression (the scene is a motel, after all). It is a method that Hopper was to perfect in his late work. And the view of dream-factory America recalls half-forgotten images of the past, of frontier days when Nature and Civilization met head-on in a way that acquired central symbolic importance for the New World.

The motifs that establish links between Hopper's different works leave (so to speak) a trail of psychological clues. They are signs of latent or repressed physical desires that are a part of American society's

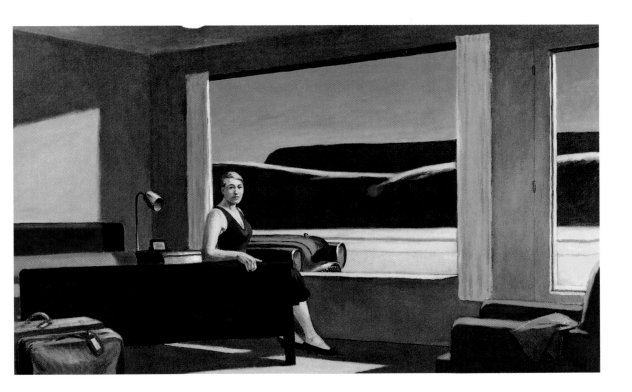

experience and perception. The pictures that present the confrontation of Nature and Civilization or invoke earlier forms of life in a natural environment are eloquent of the ways in which the physical has been repressed in the process of Civilization.

In this sense, Hopper's *Girlie Show* was by no means an isolated case in his work. This frank celebration of sex, painted in 1941, shows a middle-aged stripper in a G-string, her body picked out in the spotlight, her nipples and lips painted red and her red hair flowing. Other pictures that approach the same sexual territory do so more reticently, with Hopper's characteristic wariness. What makes *Girlie Show* important in terms of the painter's biography and psychology, though, is the fact that the woman in it is the artist's wife, Jo – as a preliminary study (p. 11) makes clear. In the study, the woman's features are identifiably Jo's. To all the other types of ambiguity in Hopper's work, in other words, we must add a specifically sexual ambiguity: on the one hand the artist is plainly projecting sexual fantasies, on the other he is channelling them into the licit confines of marital desire. This ambivalence is latent elsewhere in Hopper's art too. And it appears not only in Hopper's interpretations of the Nature/Man dichotomy but also, more straightforwardly yet obliquely too, in his paintings of city life and the world of work.

Take *South Carolina Morning* (1955; pp. 50/51), for instance. In

Western Motel, 1957
Oil on canvas, 76.8 x 127.3 cm
Yale University Art Gallery, New Haven, Connecticut, Bequest of Stephen Carlton Clark, B.A. 1903

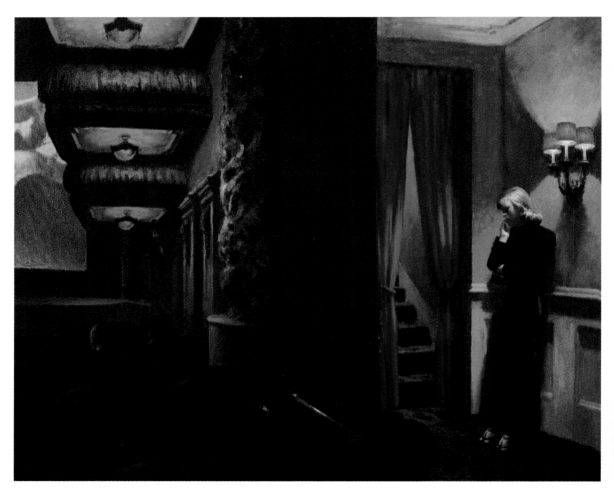

New York Movie, 1939
Oil on canvas, 81.9 x 101.9 cm
Collection, The Museum of
Modern Art, New York, Given anonymously

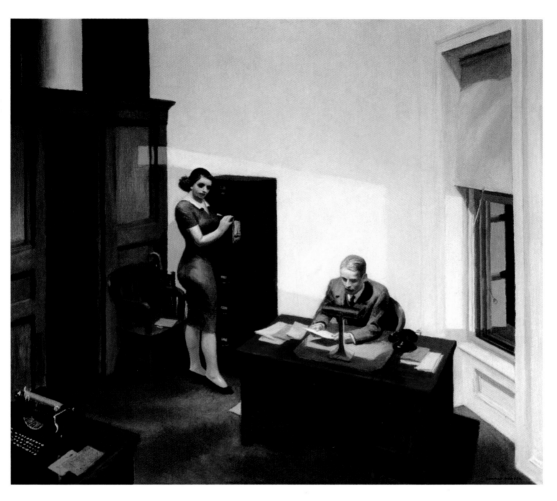

Office at Night, 1940
Oil on canvas, 56.2 x 63.5 cm
Collection Walker Art Center,
Minneapolis, Gift of the T. B. Walker
Foundation, Gilbert M. Walker Fund, 1948

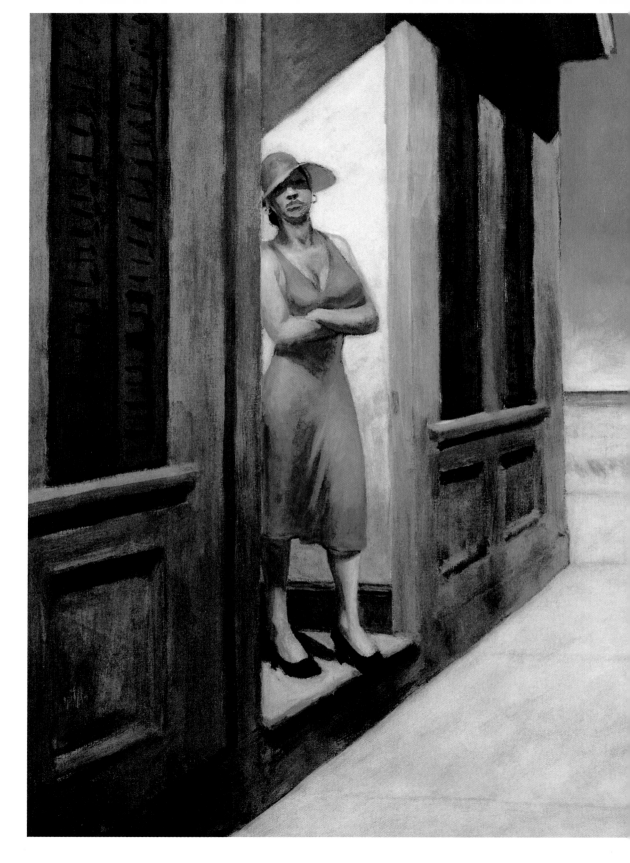

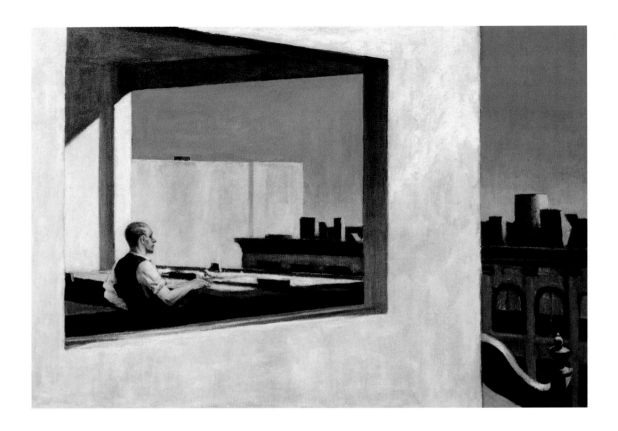

Office in a Small City, 1953
Oil on canvas, 71.7 x 101.6 cm
The Metropolitan Museum of Art,
New York, George A. Hearn Fund,
1953 (53.183)

PAGE 50/51:
South Carolina Morning, 1955
Oil on canvas, 76.2 x 101.6 cm
Collection of Whitney Museum of
American Art, New York,
Given in memory of Otto L. Spaeth
by his family 67.13

this painting the Hopper dichotomy is expressed as a tension open to psychological interpretation. The house by the beach is on a raised concrete or stone dais, like a manmade island in a natural setting. The painting's true centre is in the figure of the woman, in her red dress and black shoes. The dress is almost see-through, and the cut and fall of the fabric emphasizes the woman's physical presence. In this almost geometrical composition, the woman's body is dominant, and the effect Hopper achieves is an ambiguous one: the stance of the woman, who is dressed as if to go out, seems the epitome of motionlessness, yet at the same time there is a latent, smouldering dynamism in the sexual challenge she offers.

Hopper returned to this subject in two of his city scenes. The 1943 *Summertime* (p. 53) shows a young woman in a revealingly transparent dress on the steps of a building in the city. She is facing into the sun, and her stance has a slightly provocative quality. Behind her, the open front door is in darkness. Into the geometry of the architecture Hopper has introduced life by showing curtains blowing back from an open window (with the room beyond it again in darkness). As Hopper's preliminary studies show, these curtains were not added till the final version of the picture. The possible sexual innuendo seems clear. The emphasis on interiors that draw us in, and the phallic columns,

52

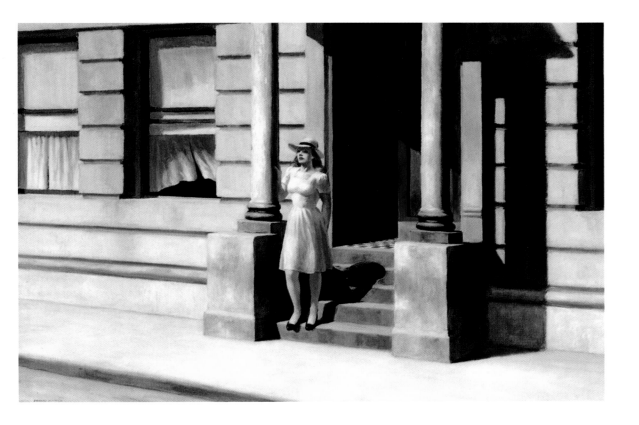

make of this streetside composition a complex of subconscious desires and projected wish-fulfilment.

In *New York Office* (1962; pp. 54/55) we see a woman in an office. We see her through a large window, and the light entering by it emphasizes her figure. She is like a film star: the window is the cinema screen onto which our (the viewer's) secret wishes are projected. Hopper used this approach with remarkable frequency. In the 1940 *Office at Night* (p. 49), for instance, the anchor of the visual focus is provided by the woman; and Hopper's preliminary studies for that work show that he chose the most provocative and sensual female stance and figure from various possibilities.

Comparison of *New York Office* and *Office at Night* highlights a significant change in Hopper's work over the twenty-odd years that separate the two paintings. In the earlier picture, the sexual tension is expressed explicitly and unambiguously. The later nighttime office scene, by contrast, shows Hopper successfully articulating latent psychological and sexual fantasies (such as are implicit in many of his works) in terms of a secret, unseen dominant.

We can consider *Office in a Small City* (1953; p. 52) another example of this. The man looking out of the office window is not merely looking at the horizon, or (say) at the façade and rooftop of

Summertime, 1943
Oil on canvas, 74 x 111.8 cm
Delaware Art Museum, Wilmington,
Gift of Dora Sexton Brown

PAGE 54/55:
New York Office, 1962
Oil on canvas, 101.6 x 139.7 cm
Collection of Montgomery Museum of Fine
Arts, The Blount Collection, Montgomery,
Alabama

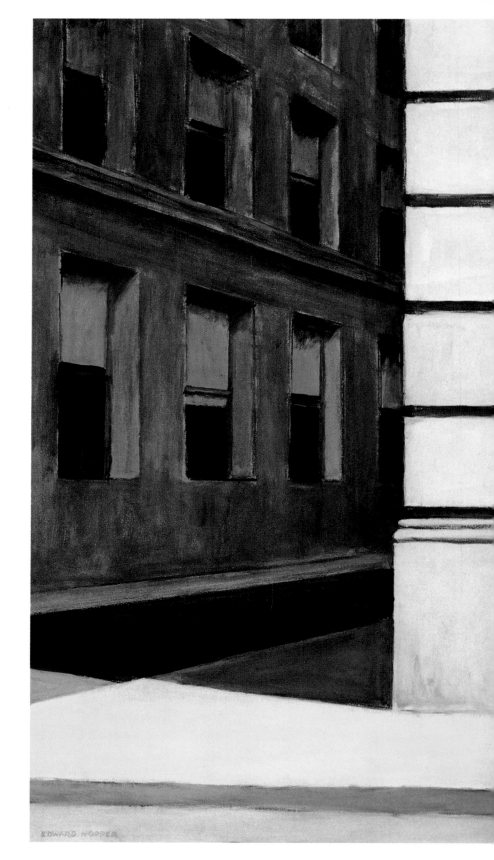

EDWARD HOPPER

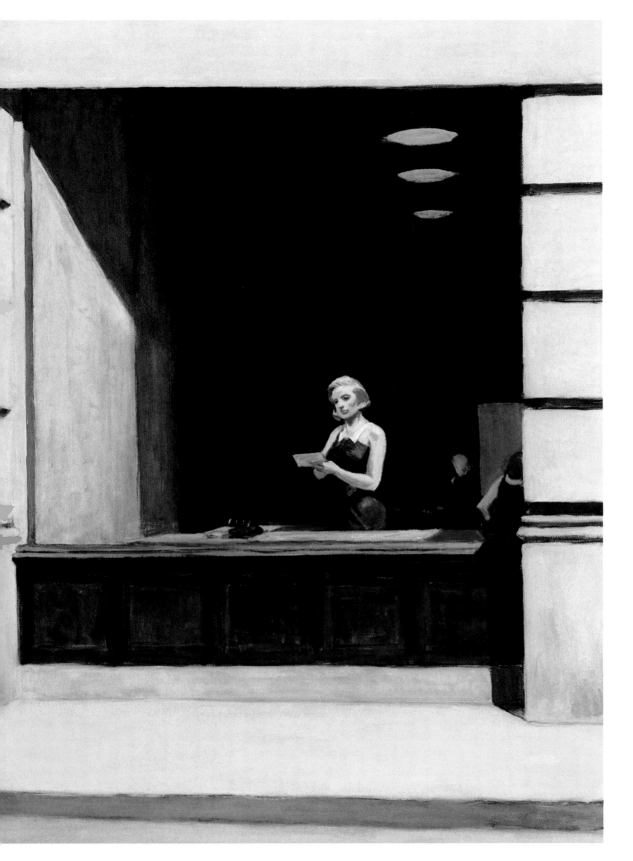

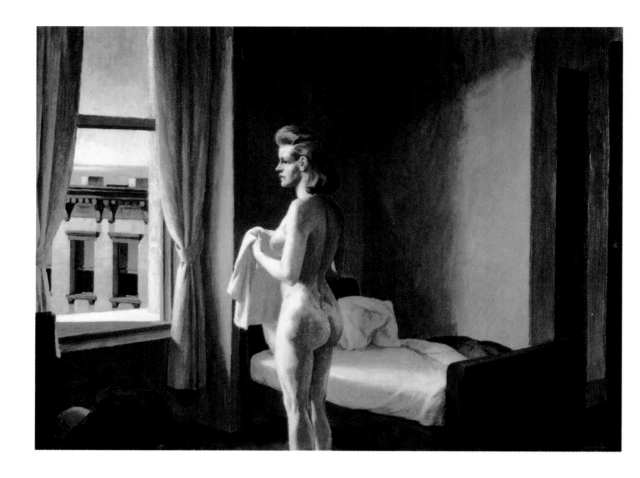

the building opposite. Rather, the rectilinear form of his office and the windowless block seen in the background at left seem to suggest that a realm of experience has been closed off to him. The house opposite dates from another age: a 19th century building, it is presented in strong colours. But we cannot see in at the windows. As for the office block the man is in, it appears from a detail at bottom right that it has a false frontage intended to give it a resemblance to older, more dignified buildings in the town – a resemblance it essentially lacks. The painting presents an image of alienation and loss. It also (not too obviously) expresses longing.

In some of Hopper's psychologically recoded compositions, the female body not only points up longing, desire, and sexual challenge but also intimacy of a kind that prompts protective instincts. In fact, it is Hopper's paintings of women that show the necessity of seeing his work in wider contexts and not merely in terms of the immediate subjects. *Morning in a City* (p. 56), painted in 1944, shows a naked woman at a window. Beyond the window is a city scene; but the woman, rather than looking out, is looking into a corner of the room

that we cannot see from our point of view; as we look at the painting, the woman makes a particularly defenceless impression. We see her from the side and rear, in an unposed position, her legs cropped (in contrast to the studies which showed her full-length; cf. p. 57); and the effect of this, together with the natural, unaware way she is holding the towel, gives her a quality of vulnerability. Not much light is entering the room, and the relative gloom makes it cavernous, somehow sealed off from the outside world where a clear and cloudless day is beginning. The woman herself is contoured by light and shadow, and the effect emphasizes her figure, yet at the same time we are given to understand that she simply happens to be standing in the light, by chance. It is not a study in glamour. The lighting upon the woman is free of intention and the use of colour dispenses with eroticizing highlights. Her naked body is merely a thing in the light, a cipher. And this is not without importance.

Compare the 1952 *Morning Sun* (p. 59). Again it shows a woman in a room, the light of the morning sun upon her. This time, though, the woman is sitting on the bed and deliberately facing the sun. Her vermilion shift looks pale against the pallor of the room, and the only colour contrast of any power is provided by the top of a building visible through the window. This woman too makes a defenceless impression. Her legs are bare, her arms are clasped at her shins, and the expression on her face (already made up) is rigid, that of a mask.

While the woman in *Morning in a City* is poised between light and shadow, unconsciously defending herself against she knows not what, holding the towel not only in front of her body but also in such a position as to ward off the sun, the woman in *Morning Light* is altogether at the mercy of light that makes an object of her. Though her position is like that of someone on a beach, the light that casts the bright quadrilateral on the wall behind her seems to have her in an intimidating grip. The interplay of projection and counter-projection (which Hopper repeatedly employs both as a subject and as a psychological substructure) has been reduced to its simplest components in this canvas. The room and the woman's body are equally at the mercy of the light. A preliminary study (p. 58) suggests that the picture was originally intended as an exercise in the effects of light on the body; and in fact this work shows Hopper's leaning to abstraction acquiring a transformational ascendancy over the idea and perspective of the painting, shifting the representational and narrative aspects into a subordinate position.

This element of abstraction, which introduced a further ambivalence into Hopper's work, can also be seen in the 1949 *High Noon* (p. 62) and *Cape Cod Morning* (p. 63), painted in 1950. The situation in *High Noon* seems clear enough at first glance. A woman, not fully dressed, is standing at her front door with an expectant air. In fact the painting is complex both in psychological and in aesthetic terms. On

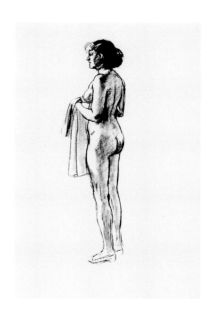

Drawing for *Morning in a City, 1944*
Conte on paper, 56.2 x 38.1 cm
Collection of Whitney Museum of American Art, New York, Josephine N. Hopper Bequest 70.294

the one hand, Hopper is using the woman for an aesthetic study in light and shadow (the shadows on her body are continuations of the geometrical shadows on the house). On the other hand, the light makes a defamiliarized impression, with the white walls contrasting sharply with the blue sky and the red shades of the chimney and foundations – and in that light the woman is exposed as if a spotlight had been focussed on her. The effect is almost obscene. Her dressing gown is open and affords an almost total view of her nakedness, and the verticals of the robe and its parting correspond to the verticals of the doorframe and door and of the gap in the curtains at the upstairs (bedroom?) window. In this emphasis on openings there is a rich, unsubtle innuendo. The light that floods the scene and the male fantasies that flood the woman's body match. The title, *High Noon*, carries ironic associations of a showdown – a meeting of male and female desires in passionate conflict, perhaps?

The consonance of woman and house reappears in *Cape Cod Morning*, albeit in a distinctly different form. In *High Noon* the woman and the house are doubly exposed, to the light and to the viewer's gaze and fantasies. In *Cape Cod Morning* the bay window where we see the woman has a protective look. The trees that mark the natural environment are leaning towards the bay, perhaps in a breeze. The woman seems to be staring out of the window, and her body, expressive of longing and desire, is emphatically modelled. And yet it is an unavailable body; the woman, supporting herself by both hands, seems well in control of her own physical domain, as it were. If we compare this painting with *Morning Sun* and other similar pictures, we see that in it Hopper has achieved a degree of abstraction that in fact has the effect of underlining the psychological component of the work. He has largely put the narrative elements of *Morning in a City* and even *Morning Sun* aside – elements that linked up to the ar-

Drawing for *Morning Sun, 1952*
Conte and pencil on paper, 30.5 x 48.1 cm
Collection of Whitney Museum of American
Art, New York, Josephine N. Hopper Bequest
70.291

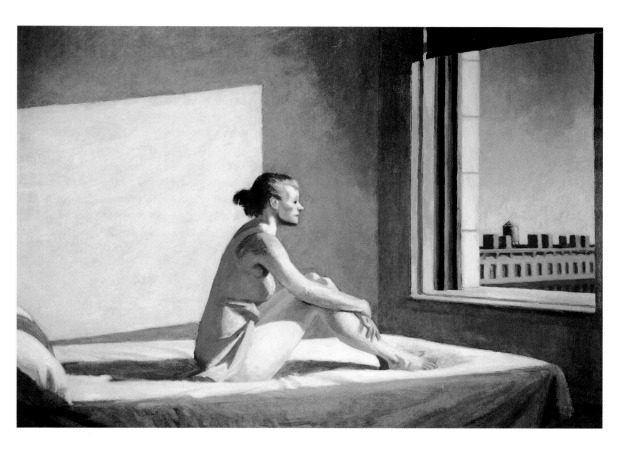

tistic tradition of window scenes as well as to aspects of the painter's own life. Both the natural exterior and the view of the interior have been defamiliarized. Nature and Civilization, human bodies and houses, are used by Hopper as signs in a system to convey subconscious images and fantasies in compositions that only have a representational function at first glance; on closer consideration we realise that the divide between (painted) image and (psychological) imago has long since ceased to apply.

Only if we bear this in mind can we understand *Seven A.M.* (1948; p. 60) correctly. The picture is divided into two sections by the whiteness of the building and the darkness of the woods. In part it is "about" the frontier of Nature and Civilization; the tension draws upon the untamed remoteness of the forest and the domestication represented by the house. Even without any human figures, the message (that the two areas cannot communicate with each other) is obvious enough. Yet the mutual exclusiveness of the two parts of the painting is also subverted by the fact that exclusion is already a constituent of each part. Unlike most of Hopper's dark, foreboding forests, this one has perspectival depth that makes it appear accessible; while the

Morning Sun, 1952
Oil on canvas, 71.4 x 101.9 cm
Columbus Museum of Art, Ohio,
Museum Purchase: Howald Fund

house, though it seems so open to our inspection, in fact only seems so. All we can actually see is part of the store, with a clock and a cash register; the right-hand window is darkened by a drawn blind, and the cropping of the picture removes the private, dwelling part of the building from our view, the available depth of the forest and the inaccessibility of the house counteract any supposedly clear distinction between what is accessible and what is not, between Civilization and Nature. And mankind is excluded from both areas.

The conceptual line represented in these pictures is extended, and expressed in tauter, denser form, in the 1951 painting *Rooms by the Sea* (p. 84). Again it is a partial view involving geometrical structures. But here the boundary of light and shadow is echoed in the boundary of the door and the water. This effect gives the work a somewhat unreal dimension. As in a Magritte, the sea appears to be a painting within a painting, with the doorframe as a picture frame. And the sightlines to the exterior confuse the perspective productively, conferring inner dynamism on the spartan space in the foreground. The view through the door creates an impression of height, and an illusion of depth. The diagonal angle of the threshhold induces an optical illusion: the horizon seems to be (very slightly) arched, and distant.

In this painting, it is the very detail in Hopper's method that creates the unreal warps in perception. The distinction between a picture and reality, which is normally the basis of any act of viewing a painting, is questioned within the painting: the sea, painted in such a way as to seem real, looks like a picture, and the room, realistically painted, looks like a product of the imagination. Our processes of perception are disoriented in direct proportion to our willingness to take these im-

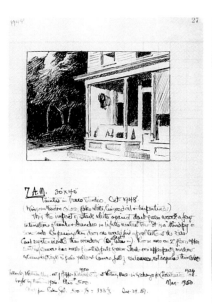

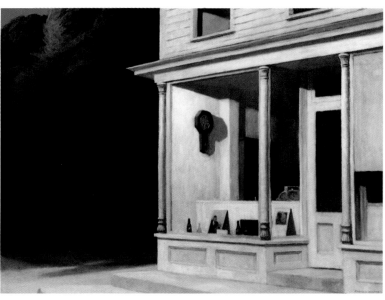

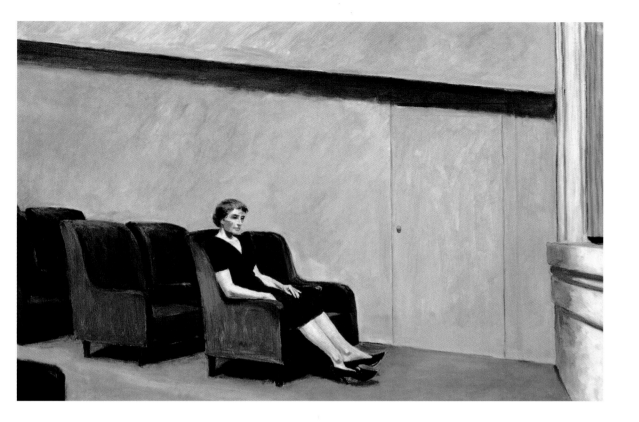

Intermission, 1963
Oil on canvas, 101.6 x 152.4 cm
Mr. und Mrs. R. Crosby Kemper

ages at face value. The picture does not aim at unambiguous representation of the real, or at distinguishing the real from the imagined; it merely reflects or mirrors.

If we relate the painting to the tradition Hopper is using and quoting, we see his subversiveness fully. He is not only questioning the relationship of image and imago. The very process of representation is made to appear a fraud, a deceitful fiction. It is an attempt to maintain the pretence of an orderly reality that is capable of representation, a reality such as the individual has long since ceased to experience. To look at Hopper's late paintings is to be continually confronted with subversion of the merely realistic.

PAGE 60 LEFT:
Journal Edward Hopper, His Works, volume III,
Seven A.M., page 27
Ink on paper, 30.2 x 18.4 cm
Whitney Museum of American Art, New York,
Special Collection, Library, Gift of Lloyd
Goodrich

PAGE 60 RIGHT:
Seven A.M., 1948
Oil on canvas, 76.2 x 101.6 cm
Collection of Whitney Museum of American
Art, New York, Purchase and exchange 50.8

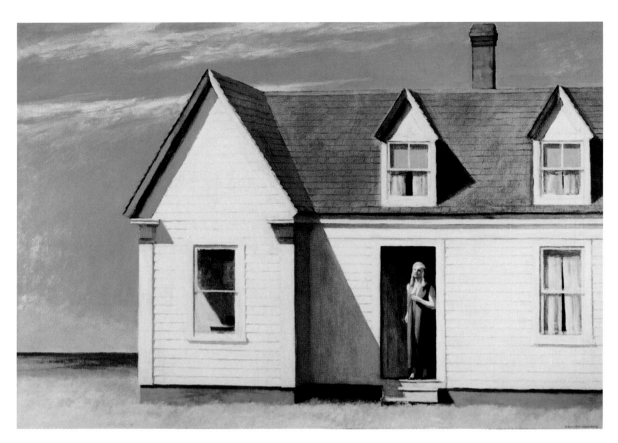

High Noon, 1949
Oil on canvas, 69.9 x 100.3 cm
The Dayton Art Institute,
Ohio, Gift of Mr. and Mrs. Anthony Haswell

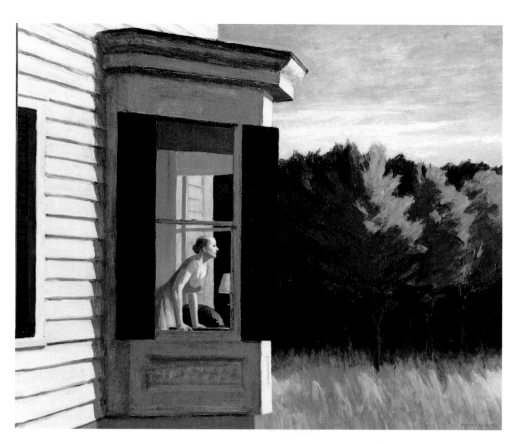

Cape Cod Morning, 1950
Oil on canvas, 86.7 x 101.9 cm
National Museum of American Art,
Washington, D.C., Gift of the Sara Roby Foundation

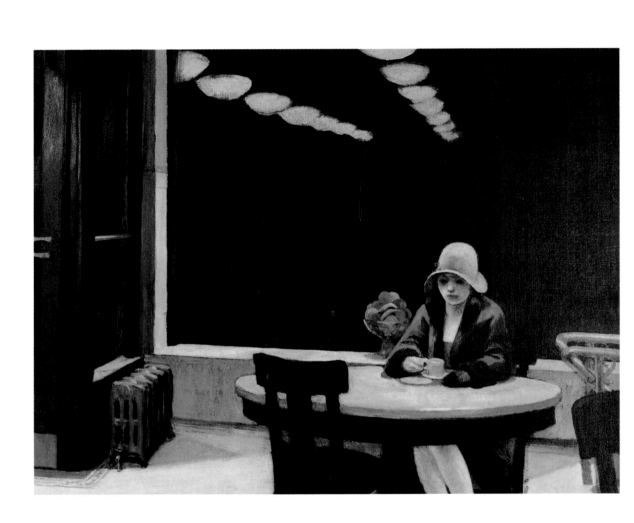

Self and Other

Time and again, Hopper provided his own commentaries on the processes by which things are metamorphosed in imagination. In the reflections on Emerson and Goethe to which we have already referred, the artist directly related the act of painting to memory, and in doing so found a statement by Degas well suited to his purpose: "It is very well to copy what one sees. It's much better to draw what one has retained in one's memory. It is a transformation in which imagination collaborates with memory. One reproduces only that which is striking, that is to say, the necessary. Thus one's recollections and invention are liberated from the tyranny which nature exerts."[18]

When Hopper, writing for the 1933 Museum of Modern Art retrospective, described his art as a "transcription [of his] most intimate impressions of nature"[19], he was not only drawing attention to the personal element in his work. He strikingly described the decisive transformational process, the metamorphic process of transfer from conception to canvas, as one of "decay"[20].

This touches upon a point that we cannot grasp clearly if we merely see Hopper as a painter of the American scene: part of what his pictures are "about" is that death or decay which all paintings in some sense represent, since they destroy the immediacy of perception through the transformation into an image.

This is at the root not only of Hopper's distinctive method but also of his critique of modern art: "I think a great deal of contemporary painting doesn't have that element (decaying from your original idea) in it at all. It's all cerebral invention. Inventions not conceived by the imagination at all. That's why I think so much contemporary painting is false. It has no intimacy."[21]

Doubtless this attack on abstract art is overstated. The distinction between the "invention" which Hopper concedes to abstract art and the "imagination" which he claims for his own art is untenable.[22] The truth is rather that Hopper's psychological version of realism, by using various techniques of defamiliarization, proves (ironically enough) to have a great deal in common with the methods of Willem de Kooning and other American abstract artists. These artists incorporate fracture in their works in order to force us to close the gaps ourselves, through close and careful viewing. Similarly, Hopper's work uses distance and detachment to create an openness to plural interpretations. Whereas the painters of the American scene tend to present their pictures as closed systems, Hopper's views provoke our reac-

Automat, 1927
Oil on canvas, 71.4 x 91.4 cm
Des Moines Art Center, Iowa, Purchased with funds of the Edmundson
Art Foundation Inc.

Detail from: *Chair Car, 1965*
Oil on canvas, 101.6 x 127 cm
Private collection, New York
(see ill. p. 67)

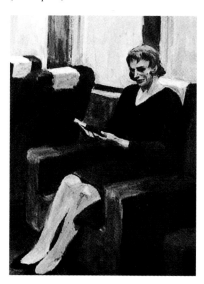

tions, establishing an intertextual exchange the meaning of which becomes apparent only in the act of perception.

The subtlety of Hopper's late paintings consists in the seamless continuity of construction and elementary representation. We can see this seamlessness as early as the 1927 *Automat* (p. 64). The ambiguity arises both from the title and from the content. The title plainly relates not only to automatic food dispensing but first and foremost to the woman in the painting herself. Her almost unseeing pose, her alienation and silence, are intensified by the geometry of the picture and the unoccupied chair. The straight rectangularity of the window is compensated by the line of lights reflected in the pane, receding into the distance. Of course that distance is deceptive, since it is really no more than a reflection of an interior. The truth is that the window affords no view of anything outside; it merely emphasizes the geometrical regularity of the restaurant and confines the woman in a glasshouse (as it were).

It is this use of reflection that provides the richest ambiguity in the painting. The title highlights the woman's situation: her very reactions in this circumscribed space are pre-determined, and furthermore the fixedness of her gaze is repeated in the stiffness of her position. Her right hand is bare, the left still gloved, and the darkness of that gloved hand contrasts with the pale skin of her face, throat, right hand and legs. And so the rigid artificiality of her surroundings extends to the woman herself and establishes the tension we detect in her body. Her physical presence is still sensuous and real, yet she has already been integrated into the order of life in a technological society. Even the

"His framing crops in ways that stimulate and frustrate attention, sometimes suggesting movement and change while fixing the subject so firmly that his best works appear like freezed frames from a lifelong movie. Hopper's viewpoints, framing, and lighting frequently appropriate movie and theater conventions."
BRIAN O'DOHERTY

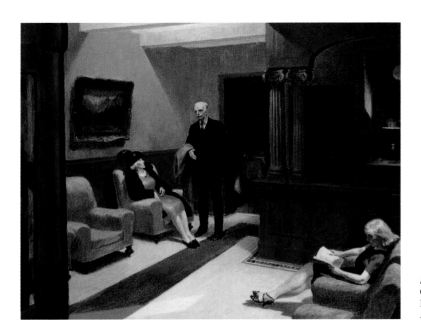

Hotel Lobby, 1943
Oil on canvas, 81.9 x 103.5 cm
Indianapolis Museum of Art, William Ray
Adams Memorial Collection

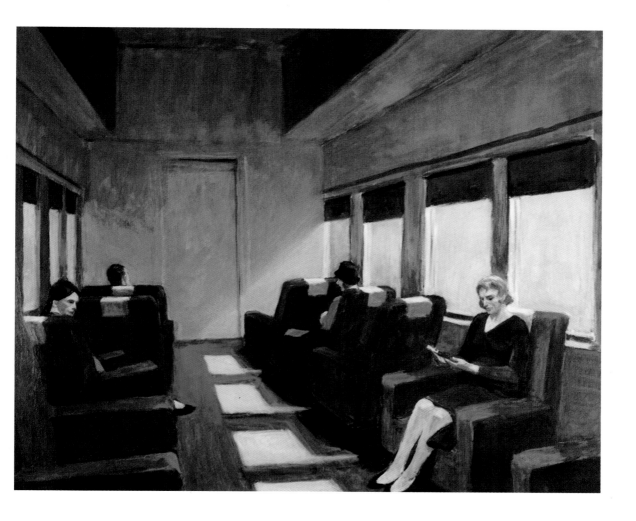

bowl of fruit, its seductive red anchoring the visual centre and echoing the woman's lipstick, is reminiscent of a lost natural life.

The 1929 *Chop Suey* (pp. 68/69) is obviously related. The windows have the effect of boundaries, and direct our attention all the more closely to the interior. Through the window at back left we see only geometrical shapes, and it is impossible to tell whether they represent a house wall beyond or the distorted reflection of the sky. The window at right affords only a sectional view out anyway; we can see a façade, a fire escape, a segment of sky, and part of the chop suey restaurant's neon sign. The two flappers, wearing typical 1920s cloche hats, the face of the woman gazing towards us heavily made up, make a rigid, puppet-like impression. This applies particularly to the woman in green, who is not so much looking at her vis-à-vis as out of the picture – at us. The woman in the red hat at the rear looks even more rigid: we see only her profile. Her dinner companion seems lost in a world of his own, and his features are lost too, in shadow.

Chair Car, 1965
Oil on canvas, 101.6 x 127 cm
Private collection, New York

PAGE 68/69:
Chop Suey, 1929
Oil on canvas, 81.3 x 96.5 cm
Collection of Mr. and Mrs. Barney
A. Ebsworth

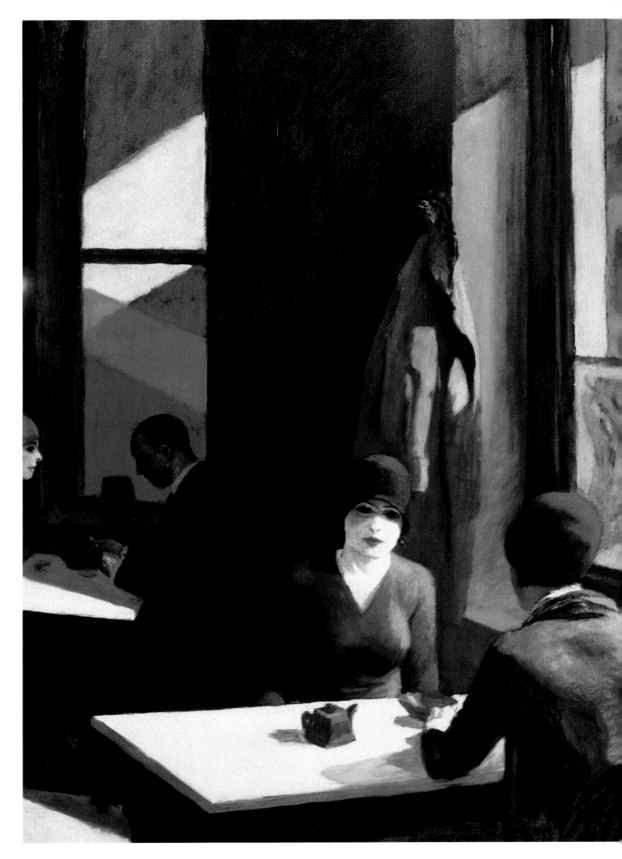

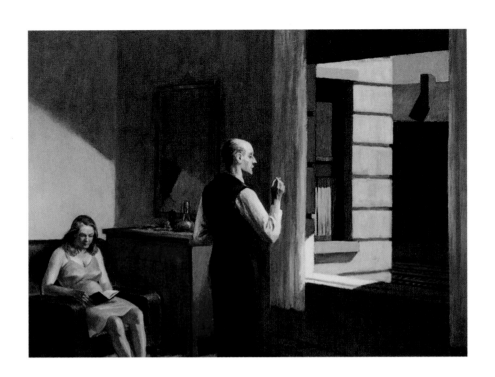

But of course the women's brash make-up signals seduction. The chop suey sign may suggest that the restaurant is in an entertainment district of town: the red of the sign matches the red of the flapper's lipstick; and the lettering of the word on the sign suggests "sex" at first glance. It is a composition in which motifs of inertia, desertion and seduction are intertwined. Like so many of Hopper's paintings, *Chop Suey* needs to be read at various levels.

Hotel Room (1931; p. 82) and *Hotel Lobby* (1943; p. 66) operate in a similarly ambiguous manner. The half-dressed woman sitting on the bed reading expresses physicality and vulnerability, and her absorption in the book prompts thoughts of a narrative context, of events that may have led up to her sitting alone in the hotel room. In *Hotel Lobby* the young woman sitting reading in front of the reception desk replaces what had still been a male figure in Hopper's preliminary studies. She makes an energetic impression, and her blonde hair and outstretched legs send a signal. Hopper presents her body in sensual terms; yet she is concentrating on her reading, and the result is an odd tension. The old-aged couple in the background, ready to go out, look as dead as tailor's dummies by comparison.

In *Hotel by a Railroad* (p. 70), which he painted in 1952, Hopper again encodes his content. The man and woman are not looking at each other, and the very absorption of the two people in their own interests establishes both common ground and the customary sense of demarcation. This is emphasized by the curtailed perspective. Through the window, at an angle to the direction the man is looking in, we can see a wall and a closed window. In the mirror (which, together with the window, is the heart of the composition) we see nothing but unclear reflections of colours. The woman's attention is fixed on her book, the man's on something we cannot see outside, and our own sightlines end in walls, closed windows and blind mirrors – in other words, the picture creates a sophisticated interplay of dynamics, boundaries and surfaces. And it also highlights the shortfall between projected wishes and what is really seen.

The 1956 *Hotel Window* (p. 72) uses a similar approach. We cannot be sure whether the woman is actually looking at something outside the window or is simply lost in thought. Either way, everything we see through the window is as inert as a stage set. The street lighting is poor and we cannot make out any of the detail on the house fronts opposite. The inertia of the scene has infected the woman, it seems; her pose is tense, and her coat seems unnaturally draped, as if frozen or billowed out by wind. The composition uses the colour and light effects to focus our attention on a corner of the room, initially at least; and this gives the woman and window a de-centred look, as if they marked a boundary in the picture. Thanks to this use of perspective and contrast, what lies outside the window seems in fact outside the picture.

The late *Chair Car* (1965; p. 67) is a continuation of the same line. Here at last the windows (two rows, converging on a perspective meeting point) coincide with the boundary of the picture in the foreground. Like the picture as a whole, they constitute a demarcation from the outside world: all we can see of that world is the light that enters the car.

At first glance it seems that the compositional conception of the 1956 *Four Lane Road* (p. 83) runs counter to this. Instead of a confined interior we have a wide-open exterior. Still, the two approaches are not entirely dissimilar. The motif of movement, merely implicit in *Chair Car*, is dominant in *Four Lane Road* – again implicitly, through the emblematic presence of the road and gas station. And the area around the gas station has very much the function of an interior as far as the man is concerned. The house (through one window of which we can see a further stretch of the woods and a second pump) meets the road at an angle which establishes a secluded corner. The man looks thoughtful, unbending; and behind him, disrupting the static unity of the compositional space, a woman is leaning out of the right-hand window, calling. The man seems unconcerned and unresponsive, as if he could not hear her at all – though he is obviously near to her. The shadow, his curious and equally silent double, has the effect of confirming him in his unyielding pose.

This polarity of arrest and movement contrasts with the essential tranquillity of the colours. The near-horizontals of the clouds, woods, grass, road, and a shadow cast by some object or building we cannot see, counteract the dynamic situation involving the two people. The fraught human scene is offset by the quiet of Nature and the static

Hotel Window, 1956
Oil on canvas, 101.6 x 139.7 cm
The Forbes Magazine Collection,
New York

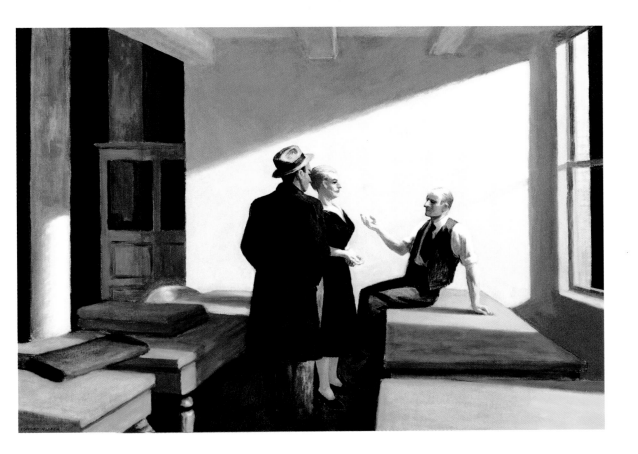

presence of the two pumps, done in strong colours, which make an almost decorative rather than technological impression.

Many of Hopper's pictures are dominated by comparable contrasts between a human scene and the space or environment. An obvious antecedent of *Four Lane Road* is *Cape Cod Evening* (p. 70), painted as early as 1939. Hopper's own comment (cf. p. 71, margin) reminds us that what seems so unique and distinctive in the painting was in fact assembled by the artist from various impressions and sketches.[23] The tension and silence prevailing between the two people, who do not make a mutually communicative impression and seem not to share hopes any more, are intensified by the setting. No path leads to the house, which is a lonely outpost of Civilization in the process of being reclaimed by Nature.

Our sense that *Cape Cod Evening* is a scene of alienation, of the end of domestic rule, without a future, grows on us if we compare the picture with the 1947 *Summer Evening* (pp. 74/75). The scene is a verandah at night. Two youngsters dressed in post-War style are standing in the wan light. It is not, surely, a sad scene of disappointed love; but it is certainly a richly ambivalent scene. The two people are lit as

Conference at Night, 1949
Oil on canvas, 70.5 x 101.6 cm
Courtesy of Wichita Art Museum, Wichita, Kansas, Collection Roland P. Murdock

PAGE 74/75:
Summer Evening, 1947
Oil on canvas, 76.2 x 106.7 cm
Private collection, Washington, D.C.

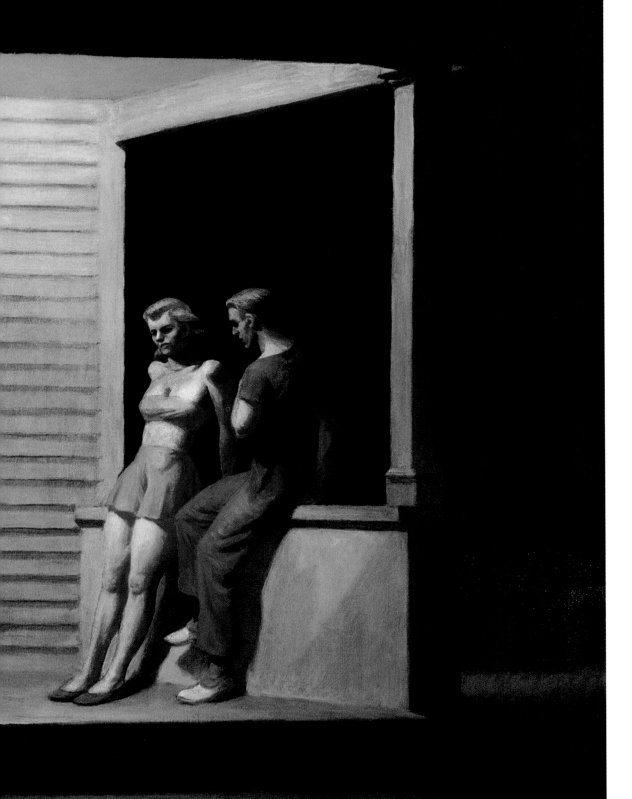

if they were on a stage, almost defenceless and yet with a manifest self-confidence. They are meeting on a clearly defined, circumscribed territory, and the final frontier in Man's onward progress involves conquest of the woman's body.

The composition and colours in both works suggest a symbolist element in Hopper's art.[24] It is not that specific meanings can be attached to identifiable symbols in these paintings; but Hopper's evocative method allusively implies narrative contexts and experiential frameworks.

Conference at Night (p. 73), done in 1949, is one of Hopper's few pictures that show people actually talking. The faces of the three people are wholly impassive, though, and they seem to be communicating through gestures and movements rather than words. This nighttime exchange is in a room without lighting, curiously lit from outside, and this idiosyncratic approach to the lighting of the scene establishes divides that are of importance to the way the three people relate. The man in the hat standing beside the woman is entirely in the shadow cast by the wall (between the window we can see and the second we cannot): he is a third man, marked off from two others and more the observer than the involved participant. We cannot interpret this Hopper any more unambiguously than we can interpret many of his other works, but the composition and painting style give the narrative implications of the scene a large suggestiveness.

This is true of *Second Story Sunlight* (1960; p. 81) too. Though Hopper himself described the picture as merely "an attempt to paint sunlight as white, with almost or no yellow pigment in the white"[25], his next statement ("Any psychological idea will have to be supplied by the viewer.") need not rule out psychological interpretation: the formulation does still admit the possibility. Hopper approved of views expressed by an art critic called Flexner in a letter, to the effect that the contrast of Nature and architecture paralleled the co-presence of crabbed age and youth in the picture.[26] We might add that (in the American spelling) the title can have two meanings: not only the second stor[e]y of the house but also a second [hi]story. If the elder woman on the balcony has the features of the woman in *Conference at Night,* the younger is like the woman in *Summer Evening.* The juxtaposition is not merely a Two Ages of Woman, though. The painting, with its twin gables topping two wings of the house, also alludes to Hopper's earlier *Two Puritans.* The parallel presentation of human beings and houses gives a certain duality to the work's texture.

Such dualities and tensions, forcing a re-assessment of a work's statement, are frequent in Hopper's late work and typical of his approach towards the end of his life. The 1961 *A Woman in the Sun* (p. 77) confirms this. The naked woman standing in a narrow strip of sunlight arouses conflicting feelings. On the one hand she seems self-confident and has a perfectly natural sense of her body. On the other

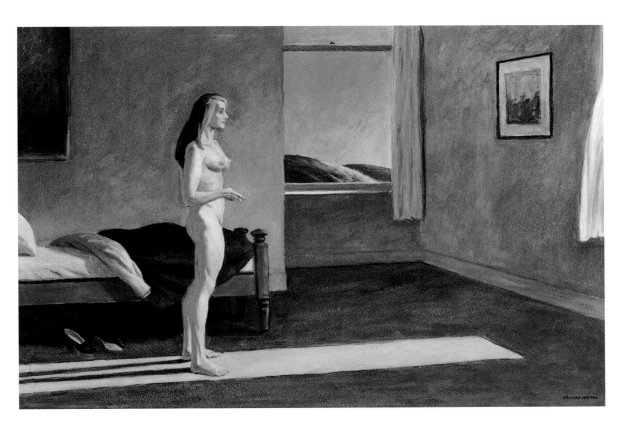

hand she looks defenceless; and the shadows of her legs are long and thin, contributing a sense of fragility. The relatively dark room admittedly has a snug, secure atmosphere, but the frontiers are uncertain. Outside the window in the background are two hills, with a powerful swell like deep waves in the sea. Together with the bright, intrusive light they give an impression of Nature invading the sanctuary of the room: in a conventional interior, of all places, Nature is going about its business of re-conquest. Hopper was of course perfectly capable of dispensing with human figures when he wanted to convey this idea, as we can see in *Rooms by the Sea* (p. 85) or the late *Sun in an Empty Room* (1963), a painting whose very title indicates the experimental approach the artist is taking.

All in all, Hopper's later work suggests that the scenes he presents might be set in Nature's realm or Civilization's without any loss one way or the other. *Nighthawks* (pp. 78/79), a city scene painted in 1942, proves the point. It is Hopper's only painting showing a curved pane of glass, the only one to make the glass itself visible. The bar's bubble of glass is an enclosure in space, hermetically sealing off the people from the city. The approach is much the same as if a divide separated them from Nature. The bar provides the only light in the

A Woman in the Sun, 1961
Oil on canvas, 101.6 x 152.4 cm
Collection of Whitney Museum of American Art, New York, 50th Anniversary gift of Mr. und Mrs. Albert Hackett in honour of Edith and Lloyd Goodrich 84.31

PAGE 78/79:
Nighthawks, 1942
Oil on canvas, 76.2 x 144 cm
Chicago, The Art Institute of Chicago, Friends of American Art Collection

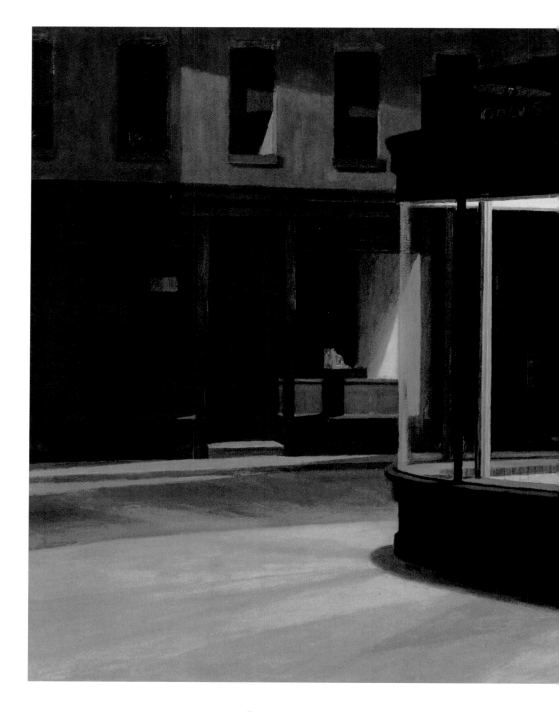

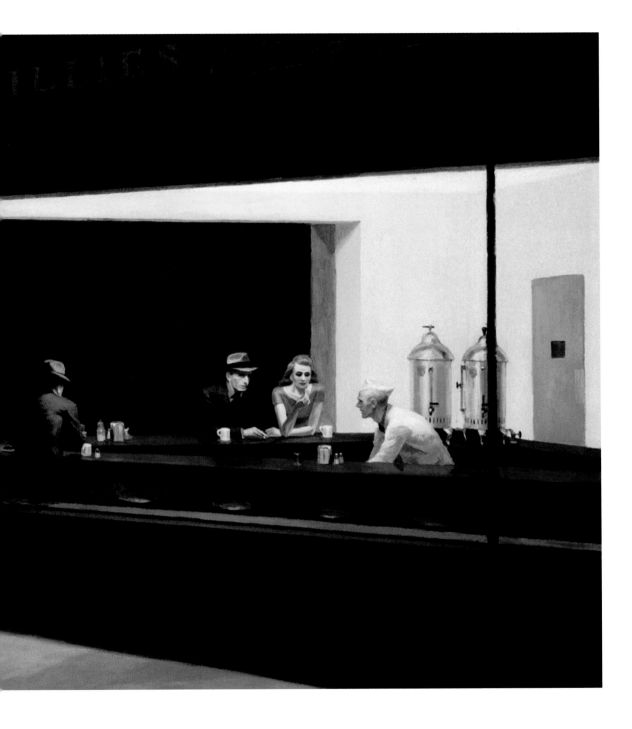

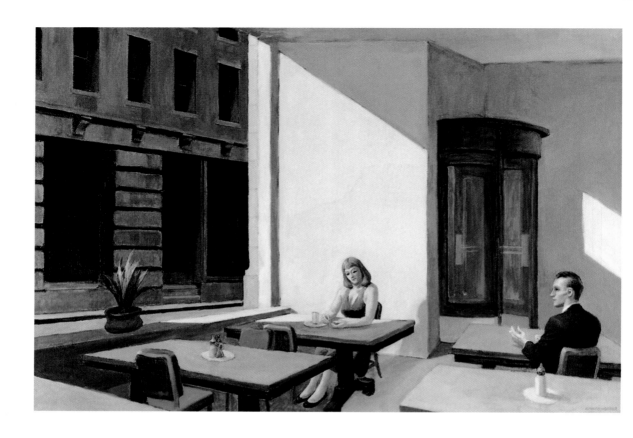

Sunlight in a Cafeteria, 1958
Oil on canvas, 102.2 x 152.7 cm
Yale University Art Gallery, New Haven,
Connecticut, Bequest of Stephen Carlton
Clark, B.A. 1903

"*Nighthawks* seems to be the way I think of a
night street. I didn't see it as particularly lone-
ly. I simplified the scene a great deal and made
the restaurant bigger. Unconsiously, probably,
I was painting the loneliness of a large city."

EDWARD HOPPER

nighttime city; and the wedge structure of the composition establishes
dynamics that come loaded with implications and are quite unlike
those of the earlier *Night Shadows* (p. 31), where the major role is
played not by light but by shadow. Hopper agreed that he was prob-
ably "painting the loneliness of a large city," unconsiously, but also
stressed the casualness of the composition, saying it showed nothing
but "a restaurant on Greenwich Avenue where two streets meet".[27]

Of course this does not account for the full impact of the painting.
It is not, or not solely, an account of lost illusions à la Humphrey Bo-
gart or James Dean. The psychological tension goes deep. Against
the desertedness of the city and the solitariness of the third drinker at
the bar, Hopper has placed the togetherness of the couple. This is the
source of the psychological effect: though the picture derives its so-
cial impact from the presentation of the bar and the background
stores, it is primarily a screen onto which discrete fantasies are pro-
jected.

Hopper returned to a related composition in the 1958 *Sunlight in a
Cafeteria* (p. 80). This painting and *Nighthawks* are like mirror im-
ages of each other. The older work is a nighttime scene looking in
from the outside, the later is an interior by daylight with a view to-

wards the outside. In *Nighthawks* mutuality is established amidst the isolation, while in *Sunlight in a Cafeteria* the bright light only serves to emphasize that divide that separates the two people. The woman, indifferent to what might be going on around her, and the man, woodenly gazing past her through the window, do not seem to be acting in the same scene, as it were. Their sightlines cross at right angles; both are caught in the light. The window itself no longer has the effect of a divide, and if it were not for the potted plant on the sill the boundary between interior and exterior would not be by any means as obvious. The light has the effect of a medium in which the two figures are held in suspended animation; wishes and desires are still present, no doubt, as the phallic salt cellar behind the man suggests.

The mirrored effects of *Nighthawks* and *Sunlight in a Cafeteria* are repeated in *Sea Watchers* (1952; p. 86) and *People in the Sun* (1960; p. 87). In these paintings the scenario is radically different. Both works show people in a natural setting, turned to the sun. In *Sea Watchers*, the silence of the couple produces psychological tension, a tension that is articulated in the compositional lines of the picture. The sea and the dais provide horizontals, while the foreshortening of the house is emphasized by the perspectival reduction of the second beyond it. These structural lines not only give depth to the painted space; they dramatize it. The towels billowing in a breeze on the line in the foreground contrast strikingly with the placid calm of the rest of the picture, from foreground to sea, and particularly with the frozen attitudes of the couple.

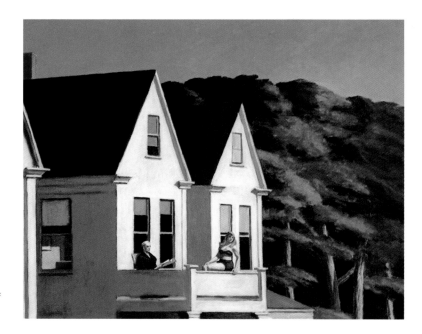

Second Story Sunlight, 1960
Oil on canvas, 101.6 x 127 cm
Collection of Whitney Museum of American Art, New York, Purchased with funds from the Friends of the Whitney Museum of American Art 60.54

It is this frozen arrest that provides the psychological depth of the painting; the technical dynamics underline it. The man and woman are not looking out to the horizon but down at the beach and the waves, and their gaze runs parallel to the horizontals. Though their bodies are close, they make a separate, closed-off impression. Self and other, as so often in Hopper (compare *Nighthawks* or *Hotel by a Railroad*), exist side by side but seem unlikely to achieve any real communication.

The contrast of movement and stasis, a core contrast in Edward Hopper's work and one which seems generally to signal these psychological problems of communication, is foregrounded through the structure of *Sea Watchers*. In *People in the Sun* it is treated more economically, even reductively. We see the group at an angle, from somewhat to their rear. The people in the front row are sitting in line, at a slight angle to the sun. The perimeter of the terrace runs almost exactly parallel to the valley and the chain of hills beyond. What results is a contrast of two sets of structural lines; and the energy felt in this effect contrasts in turn with the repose of the people. The only figure who is not frozen and staring is the man at left, the reader, who stands for absorption and concentration, positive values of the self that continually recur in Hopper's work in defensive distinction from the uninspiring woodenness of others.

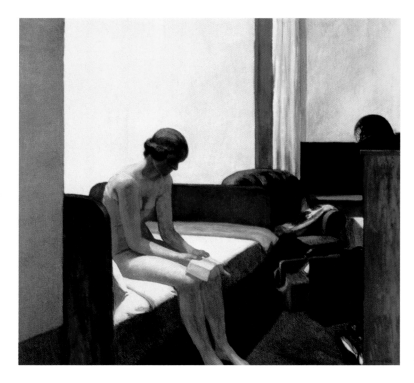

Hotel Room, 1931
Oil on canvas, 152.4 x 165.7 cm
Thyssen-Bornemisza Foundation, Lugano, Switzerland

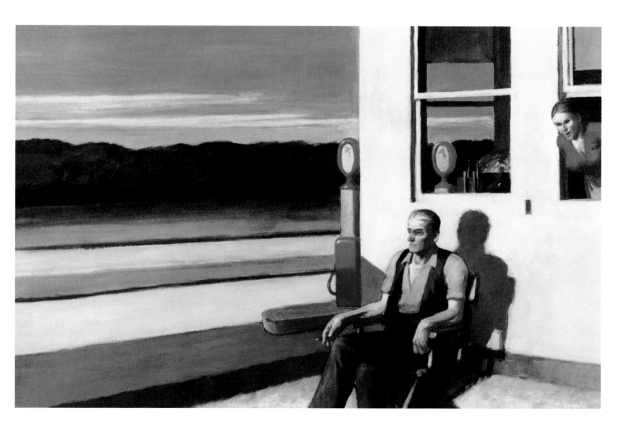

In a sense, this picture is a recapitulation of the core Hopper. It shows that Hopper's scenes of American Nature (like his scenes set in the realm of Civilization) represent the divide between Nature and Civilization as dynamic, in flux, reversible. It also highlights transformation. A psychological condition is transformed into a correlative, a projection, an observed scene that expresses silence and arrest; and Nature itself is frozen, as on a postcard. But this frozen condition is not only apparent to us as we look at the picture, but also determines the perceptions and behaviour of the people in it. In freezing Nature into a panoramic view, and intertwining our own mode of perception with that of the people portrayed, Hopper has transformed a scene that appears at first glance to be traditional mimetic realism into something evocative, psychologically allusive, richly associative. And the structural laws of his approach operate beyond mere representation.

Four Lane Road, 1956
Oil on canvas, 69.8 x 105.4 cm
Private collection

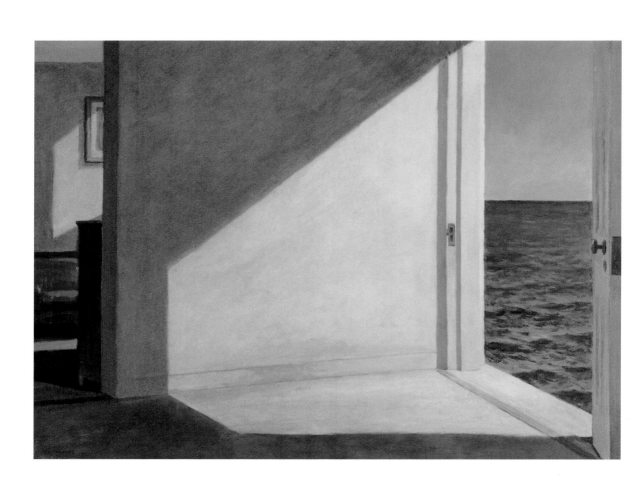

Transformations of the Real: Hopper as Modernist

Realistic though they may seem, Edward Hopper's paintings are not mere representations of supposed reality. They deconstruct and reconstruct the real, transforming it beyond the purely experiential. Like the views Hopper regularly included as pictures within his pictures, a characteristic Hopper composition is not first and foremost an image of visible fact but rather a *gestalt* created out of breakdown and fracture in the process of perception and indeed the capacity to perceive. His works have aptly been dubbed metaphors of silence.[28] Just as all utterance is governed by what remains unsaid, and by silence, so too Hopper's art has its centre of gravity in what is not actually visible in the paintings. Hopper's art enacts ways of seeing and understanding that anchor superficial situations in profound depths.

There is a clear continuity from what was sketched in his early works through a more fully developed expression in the middle phase to the full, complex flowering of the artist's late work. Narrative as Hopper's late paintings may well appear, they invariably draw their impact from the awareness of what is unexpressed, whether the subject is people or the nature of modern life. Hopper's pictures are about tension and isolation, and the silence indicated in many of his situations has major dramatic and communicative value in his aesthetic scheme. The rigorous structure of his paintings, their limited subject matter and Hopper's experimental use of light create an impression of calm and concentration which can itself be seen as a response to society.

The meaning of Hopper's late pictures of people and cities can best be understood if we compare Reginald Marsh's work of the 1930s and 1940s. Marsh too was painting life in the modern city. He too was drawing attention to social gaps and tensions, and his work often showed women as catalysts of societal change. Marsh did work that we might label as social criticism, such as *Bowery Drunks*, but in the course of his career he tended more and more to paint pictures in which women had emancipated status yet were also objects of male fantasy at the same time. *Paramount Pictures* (1934) blurs the distinction between women in Hollywood's dream world and the real women at the entrance to the cinema. In the 1936 *Steeplechase Park* (p. 10), we see women in a ring, as if they were being served up to male desire. *Eyes Examined* (1946) shows a woman in the desirable prime of youth; the men look almost repellent in comparison.

These simplified close-focus views of aspects of society, with their

"Maybe I am not very human. What I wanted to do was to paint sunlight on the side of a house." EDWARD HOPPER

Rooms by the Sea, 1951
Oil on canvas, 73.7 x 101.6 cm
Yale University Art Gallery, New Haven, Connecticut, Bequest of Stephen Carlton Clark, B.A. 1903

unambiguous sexual coding, are foreign to the art of Edward Hopper. Where Marsh's pictures (like John Sloan's) zoom in with the merciless eye of a critic intent on stripping his subject bare, Hopper's strikingly preserve a certain detachment and distance. He himself reticently described his art as ". . . memories of glimpses of rooms seen from the streets in the eastside, (. . .) simply a piece of New York, the city that interests me so much . . ."[29] Nonetheless, even his seemingly most casual of pictures are loaded with significance – consciously in the case of his compositional structure, unconsciously in terms of their suggestive power. Time and again his idiosyncratic use of perspective, seen with full striking force for the first time in *Night Shadows* (p. 31), shows that his scrutiny is finally aimed at locating ways of expressing himself rather than recording what he might happen to see before him. In this respect, Hopper always remained in Degas's debt, owing a great deal to the French painter's concept of the transformation of the real through imagination and memory.

Hopper's city scenes restate the closed-off, pathless inertia so characteristic of his natural scenes featuring roads and railway track. Hopper's settings are not always easily accessible, and imply a barrier between the scene and ourselves as viewers. This highlighting of isolation, this reductiveness, is something Hopper has in common with Marsh and other painters of the American Scene: like them, he rejected contemporary American attempts to translate hard, experiential reality into sugared, illusory images. And in the process Hopper succeeded in capturing social reality and the nature of city life – precisely because he broke through the superficial, quasi-utopian paradigms of thought and behaviour which he had still (necessarily) paid

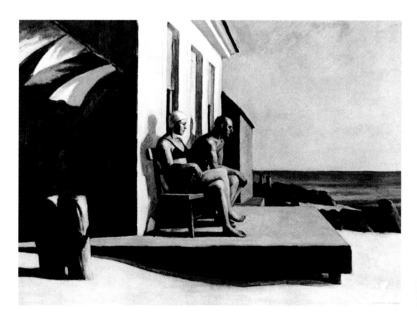

Sea Watchers, 1952
Oil on canvas, 76.2 x 101.6 cm
Private collection

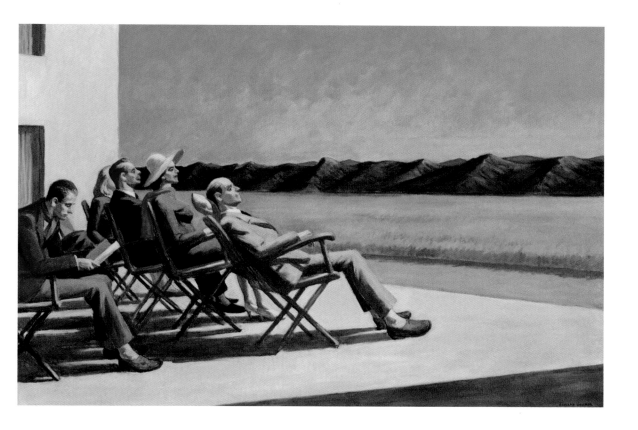

lip service to in his days as a commercial illustrator (cf. p. 95, below). In his paintings, Hopper was out to transform into an image what he so often and so skilfully achieved in his caricature work: the interface between patterns of experience fixed by society and the need for individual experience. We can detect his reaction against social appearances as early as 1927, in his response to Hemingway's short story 'The Killers', published in a magazine for which Hopper did illustration work: "It is refreshing to come upon such a honest piece of work in an American magazine, after wading through the vast sea of sugar-coated mush that makes up the most of our fiction. Of the concessions to popular prejudices, the side stepping of truth and the ingenious mechanism of trick ending there is no taint in this story."[30]

This notwithstanding, it would be wrong to suppose there were a simple contrast between Hopper's commercial work and his mature art. Rather, his later work used visual material from the commercial realm in the form of quotation or reminiscence or for decorative purposes. We might compare Charles Sheeler's Precisionism of the 1920s and 1930s, or the photo-realism of Richard Estes in the 1970s. But we would have to add that in Hopper's representations of twentieth century experience there is always an awareness of the tension

People in the Sun, 1960
Oil on canvas, 102.6 x 153.4 cm
National Museum of American Art, Washington, D.C., Gift of S.C. Johnson & Son, Inc.

Andrew Wyeth
Christina's World, 1948
Tempera on gesso panel, 81.9 x 121.3 cm
Collection, The Museum of Modern Art,
New York

between the consumer society's pressures and the wishes and needs of
the individual.

In retrospect, the evolution of Hopper's late work strikes us as hav-
ing been logically anticipated by his 1920s position between the Ash
Can School (Robert Henri, John Sloan and others) and the Fourteenth
Street School of Marsh and others. Reacting to the Modernism that en-
tered the USA through the 1913 Armory Show and which Alfred
Stieglitz's famous gallery, '291', so powerfully advocated, the Ash
Can School took to realistic street scenes and pictures of society as a
whole. But theirs was essentially a 19th century tradition. Pictures
such as Sloan's *Bleecker Street, Saturday Night* (1918) were basically
picturesque genre responses to the industrialization of society. Marsh
and other Fourteenth Street School painters rejected the tendency to
the idyllic, and used their accounts of city life to satirically decode so-
cial structures and values.

Edward Hopper and Charles Burchfield (who was influenced by
and in turn influenced Hopper; cf. p. 91) went a way of their own
from the 1920s on, painting in a style of natural expression that
derived from the example of Robert Henri. We see this most clearly in
the choice of subjects. Both artists (but Burchfield in particular) gravi-
tated towards the intermediate zone between urban and rural America.
They dispensed with shallow social criticism and instead tried to
grasp the everyday scene in such a way as to render it both an image
and a screen for the projection of wishes and fantasies. In his late
work, Hopper not only perfected this approach but also succeeded in
playing off the surface against the deeper meaning in such a way that
the subversive power that resulted far exceeded mere judgement or
critique. We must bear in mind that Hopper, in his 1928 article on
Burchfield, stressed the tandem importance of observation and inspira-

tion – which affords us a clue to the effect of his own late works. That effect derives to a large extent from careful observation of the everyday. "No mood has been so mean as to seem unworthy of interpretation,"[31] wrote Hopper. The tension between realistic representation and the painter's transformation can be traced to the smallest of details. Motifs that appear in many of Hopper's paintings can still be seen in New York, Gloucester and Cape Cod – as comparison of the works with photographs shows.[32] At the same time, of course, the comparison demonstrates that the impact of Hopper's pictures derives from transformation of immediate perceived reality into an aesthetic idea: the painted image relates to concepts that preceded the act of seeing, and what looks realistic on the canvas acquires a dimension of déjà-vu.[33] This is not a matter of purely individual experience requiring psychological decoding, but rather draws upon a collective store of images and concepts.

This approach was highly developed, and even further complicated, in Hopper's late work. On the one hand he was decoding the relation between preconceptions in our ways of seeing and simple mimetic representation, and was showing both to be subject to an overarching mystery. On the other hand Hopper was investigating the gaps between motif, content and aesthetic effect.[34] This is the source of the calm and also of the detachment in Hopper's work. It is as if the things in his paintings were seen behind glass. This tense interplay of realism and abstraction, representation and transformation, prompts conceptual responses, as is shown by the fact that we tend to use linguistic means to account for the impact of Hopper's art, for all its supposed lack of ambiguity. There is a sense of gaps and fissure in his work, and critics like to fill the gaps with verbal metaphors. They

Eric Fischl
Bad Boy, 1981
Oil on canvas, 168 x 244 cm
Saatchi Collection, London, Courtesy of Mary Boone Gallery, New York

Eric Fischl
A Brief History of North Africa, 1985
Oil on canvas, 223.5 x 304.8 cm
Courtesy of Mary Boone Gallery, New York

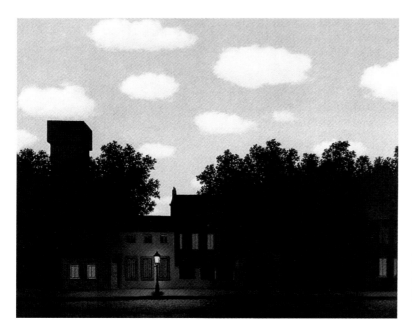

René Magritte
L'Empire des Lumières II, 1950
Oil on canvas, 79 x 99 cm
Collection, The Museum of Modern Art, New
York, Gift of Dominique and John de Menil,
1951

transform the specific perceptions provoked by the pictures into language. It is a phenomenon Hopper's critics have of course been aware of: "Hopper's scenes not only invite literal comments on the observer and observed, they play a game of hide-and-seek in which the artist's pursuit of his identity is pursued by the audience. The elements of such a game are part of the picture's content – disappearance, silence, stealth, suspense, bafflement, glimpses – but no denouement."[35]

The transformational and imaginative power generated by Hopper's art is not purely conceptual in character. To an unusual extent, his scenes of isolation and alienation not only probe the relations of Man and Nature but also involve questions concerning the viewer's identity. The observers of his scenes, who sometimes have an obviously voyeurish streak, tend to be identified with us as outside viewers, in a manner that implicates us in the psychological fabric of the scenes. At the same time, the psychology of Hopper's paintings is by no means always unambiguous: like his use of traditional, realistic mimesis, it tends to be overlaid with abstraction.

For these reasons, classifying Hopper as a painter of the American Scene seems questionable. He himself rejected such pigeonholing. Writing of Thomas Hart Benton, John Stewart Curry and other Midwest painters, he declared: "I think the American Scene painters caricatured America. I always wanted to do myself. The French painters didn't talk about the 'French Scene', or the English painters about the 'English Scene'".[36] Still, the compositions that articulate this distinctive sense of things American are based on a synthesis, a psychologi-

Charles Burchfield
Six O'Clock, 1936
Watercolour on paper, 61 x 76.2 cm
Everson Museum of Art, Syracuse, New York,
Museum Purchase, Jennie Dickson Buck Fund

cally encoded and intellectually organized configuration of observations, impressions and thoughts. And they use a visual idiom that draws on a limited repertoire of realistic props. [37]

This clarifies the twofold importance Hopper's work is now seen to possess. His individual transformation of American images coincides with collective myths and concepts; at the same time, his work goes far beyond this, expressing a social condition in which a coherent sense of the real has been lost. It is primarily Hopper's meticulous use of detail that points up the psychological and epistemological ruptures between experience and idea, collective myth and social fact. The perceptions adumbrated in his paintings are modified by our own perceiving eye.

Time and again, Hopper's late work shows that realism now consists in a ludic manipulation of real props and the perspectives of the viewer. Everything that appears capable of unambiguous decoding is in fact a construct; and everything constructed is endowed with a psychological radiance that makes it far more interesting than anything merely represented.

In reality the "imagination" Hopper opposed to abstract art's mere "invention" is very closely related to it. His psychological recoding of the real is at once a transformation and an abstraction. And its aim is not a single, unambiguous meaning. Rather, his art is plural and ambiguous. Just as abstract artists transform the given subject into a system of signs which allow us various kinds of access and permit the projection of our fantasies, so Hopper's pictures use detachment to es-

tablish an openness that is available to many and various interpretations. The painters of the American Scene created closed contexts in their work; but Hopper's art involves the viewer in its conception, in its dramaturgy, and establishes what postmodernist theory has dubbed intertextuality.

But before we conclude we should relate Hopper's paintings to two lines that have been of major significance in Modernist art and in the evolution of postmodernism. The principle of defamiliarizing authentic perceived reality relates Hopper's art to René Magritte's; and the use of images of Civilization suggests comparison with postmodern artists who re-introduce mimetic strategies into their work, such as Eric Fischl.

Looking at Magritte's *L'Empire des Lumières II* (p. 90), we find our perceptual responses disoriented if we take the scene at face value. This effect is characteristic of Hopper's work too. Magritte aimed at a moment of clear vision beyond anything that was methodologically or psychologically explicable. What is implied in Hopper's late work and is in fact fully achieved in *Rooms by the Sea* or *Sun in an Empty Room* is even more pronounced in Magritte. For the Belgian artist, the creation of a visual image was no longer a matter of straightforward representation of reality nor did it involve clear divides between the real, the imaginary and the created image. As Michel Foucault has observed, Magritte's pictures are like a mirror in which things that are disparate in the world respond to each other. The ludic use of pictures within pictures (which Hopper employs as well) is the fundamental mode of thought for Magritte. The interplay of the real, the imaginary and the created image *is* the reality of a picture, in Magritte's eyes. In his essay 'Words and Images' he programmatically insisted that all the indications suggested there was little connection between objects and the means used to represent them.

At first glance, the narrative elements Hopper's art has in common with that of (say) Eric Fischl or Andrew Wyeth would appear to be the very opposite of this principle of abstraction. But in fact the two approaches offer mutual reinforcement. Fischl continues a line present in Hopper: the technique of dual coding, loading images that seem realistic with unconscious and often sexual significance.

Fischl not only paints mankind as a creature of Civilization but also, more nakedly than Hopper, directs attention to psychological and historical questions. With white America in mind he paints *A Brief History of North Africa* (p. 89), for instance, emphasizing black tradition. Or he presents voyeurish views of erotic scenes – such as *Bad Boy* (p. 89) or *Birthday Boy* – which not only suggest a private obsession but also recall the processes by which society represses desires, processes which constitute the secret heart of Edward Hopper's art as well.

The aesthetic games-playing in Hopper's paintings has its more inti-

Two Comedians, 1965
Oil on canvas, 73.7 x 101.6 cm
Private collection

mate side, a side that links him to the Andrew Wyeth of *Christina's World* (p. 88) and particularly the autobiographically coloured Helga pictures. Hopper also plainly considers the Game of Art to be one with the Game of Life. His last picture, *Two Comedians* (p. 93), painted in 1965, shows two clowns on a stage, bowing in farewell in front of a closed curtain. Their features leave us in no doubt that the two figures are Edward and Jo Hopper. For both of them, the games the painter plays with the real are evidently a role to be played. It is a totally serious clue to Hopper's view of realism. His realism was never merely reproduction of the visible, the given, the actual; he was not interested in mimetic representation as such. Rather, image and imagination, and representation and aesthetic construction, were interdependent in his work. It is only the ludic interplay between images of the real and the viewer's gaze decoding the real that finally establishes the reality of Edward Hopper's art.

Edward Hopper 1882–1967:
A Chronology

Edward Hopper in Paris, 1907

1882 Born on 22 July, son of Garrett Henry Hopper and Elizabeth Griffiths Smith-Hopper, in Nyack, New York.

1899–1900 After high school he enrolls in a New York school for illustrators.

1900–1906 Studies illustration and then painting at the New York School of Art (Chase School). He is taught by Robert Henri and Kenneth Hayes Miller.

1906 In Europe. Hopper visits England, Holland, Germany and Belgium, but spends most of his time in Paris.

1908 Settles in New York and works as a commercial artist, painting in his free time. First exhibition, with other pupils of Henri, at Harmonie Club in New York.

1909 Second visit to Europe. He stays in France, chiefly spending his time in Paris.

1910 Third trip to Europe: France and Spain.

1912 Painting in Gloucester, Massachusetts, and later at Ogunquit, Maine.

1913 Exhibits in the Armory Show and exhibits one oil, *Sailing.*

1915 Takes up etching and produces about fifty plates in the next eight years.

1916 Spends the summer working at Monhegan, Maine.

1920 First one-man show, of Paris oils, at Whitney Studio Club.

1922 Exhibits caricatures at Studio Club.

1923 Begins to paint watercolours. Receives the Chicago Society of Etchers Logan Prize.

1924 July 9: marries Josephine (Jo) Verstille Nivison. November: exhibits recent watercolours at the Frank K.M. Rehn Gallery in New York.

1926 April: exhibition of prints and watercolours at St. Botolph Club, Boston. Summer at Rockland, Maine.

Jo in Wyoming, 1946
Watercolour on paper, 35.4 x 50.8 cm
Collection of Whitney Museum of American Art, New York, Josephine N. Hopper Bequest 70.1159

Edward and Josephine Hopper in South Truro, Massachusetts, 1960

1927 February: exhibition of oils, prints and watercolours at Rehn Gallery.

1928 November: exhibits watercolours at the Morgan Memorial, Hartford, Connecticut.

1929 January: exhibition at Rehn Gallery. December: work included in 'Paintings by Nineteen Living Americans' at the Museum of Modern Art, New York.

1930 Summer at South Truro, Cape Cod, renting Burly Cobb's house.

1933 Builds a house at South Truro, which is the Hoppers' summer home henceforth. Motoring in Canada and Maine. November: retrospective in Museum of Modern Art, New York.

1934 January: most of the retrospective is seen at the Arts Club of Chicago. Motoring in Colorado, Utah, Nevada, California, Oregon and Wyoming.

1935 Awarded Pennsylvania Academy of Fine Arts Temple Gold Medal, and First Purchase Prize in Watercolor by Worcester Art Museum, Massachusetts.

1937 Receives the first W.A. Clark Prize and the Corcoran Gold Medal of the Corcoran Gallery of Art, Washington D.C.

1940 Motoring on West Coast.

1942 Awarded Ada S. Garrett Prize, Art Institute of Chicago.

1943 To Mexico by rail.

1945 Elected a member of the National Institute of Arts and Letters.

1946 To Mexico by car.

1950 February–March: retrospective at Whitney Museum of American Art, New York; later seen at the Museum of Fine Arts, Boston (April) and the Detroit Institute of Arts (June).

1951 Third visit to Mexico. Brief stay in Santa Fé.

1952 The American Federation of Arts nominates Hopper one of four American artists representing the USA at the Venice Biennale. Fourth visit to Mexico (December 1952–March 1953).

1953 Honorary Doctor of Fine Arts, Art Institute of Chicago. Honorary Doctor of Letters, Rutgers University.

1954 Receives First Prize for Watercolor, Butler Art Institute, Youngstown, Ohio.

1955 Elected to American Academy of Art and Letters, and awarded the Academy's Gold Medal for Painting. Fifth trip to Mexico.

1956 Huntington Hartford Foundation fellowship.

1957 Receives New York Board of Trade Salute to the Arts Award, and First Prize, Fourth International Hallmark Art Award.

1959 November: one-man show at Currier Gallery of Arts, moving to Rhode Island School of Design (December) and Wadsworth Atheneum, Hartford, Connecticut (January 1960).

Caricature of Hopper as a boy with books on Freud and Jung, c. 1925–35
Pencil on paper, 10.5 x 7.9 cm
Private collection

L'Année Terrible: On the Rooftops, 1906–07 or 1909
Illustration for Victor Hugo's Book of Poems
Watercolour and ink on paper, 55.2 x 37.5 cm
Collection of Whitney Museum of American Art, New York, Josephine N. Hopper Bequest 70.1338

1960 Receives Art in America Annual Award.

1962 October: retrospective exhibition of graphic work, Philadelphia Museum of Art, travelling to Worcester Art Museum, Massachusetts.

Cover: Hotel Management,
6 (November 1924)

1963 Retrospective in Arizona Art Gallery. Receives award from St. Botolph Club, Boston.

1964 September–November: the major retrospective in the Whitney Museum of American Art, New York, is a triumphant success with critics and public alike. It tours to Chicago, and in 1965 to Detroit and St. Louis. Hopper receives. M.V. Kohnstamm Prize for Painting from the Art Institute of Chicago.

1965 Honorary Doctor of Fine Arts, Philadelphia College of Art. Paints his last picture, *Two Comedians.*

1966 Awarded Edward McDowell Medal.

1967 Major US representative at São Paulo Biennale. After several weeks in hospital, Hopper dies at his New York studio on 15 May. His wife Jo also dies within a year of him.

Notes

1 Carl Baldwin: 'Realism. The American Main-stream', in *Réalités*, April 1973, p. 117. Cf. John Perrault: 'Hopper: Relentless realism, American light', in *Village Voice*, 23 September 1971, p. 27.
2 Peter Handke: *Die Lehre der Sainte-Victoire*, Frankfurt, 1980, pp. 18–19.
3 Quoted in Lloyd Goodrich: *Edward Hopper*, New York, 1971 (1983 reprint), p. 152.
4 Robert Hobbs: *Edward Hopper*, New York, 1987, p. 23.
5 ibid, p. 23
6 On Hopper in Paris cf. Levin Gail: *Edward Hopper, the Art and the Artist*, Whitney Museum of American Art, New York, 1980.
7 For Hopper's links to the realism of artists such as Wyeth, see Hobbs, op. cit., p. 110.
8 For Hopper's views on Sloan and Marsh, cf. Hobbs, op. cit., p. 42. For correspondences with the literary work of Theodore Dreiser, Sherwood Anderson, Sinclair Lewis, John Dos Passos, Thomas Wolfe and William Faulkner, cf. Goodrich, op. cit., p. 88.
9 The passage comes from Goethe's letter to Jacobi of 21 August 1774.
10 Edward Hopper: 'Charles Burchfield: American', in *The Arts* 14 (July 1928), pp. 5–12. The quoted comment occurs on p. 5.
11 ibid, p. 5.
l2 ibid, p. 7.
13 ibid, p. 7.
l4 Hobbs, op. cit., p. 65.
15 For Hopper's links to the Transcendentalists, see Hobbs, op. cit., p. 67.
l6 ibid, p. 83.
17 ibid, p. 83.
18 Cf. Brian O'Doherty: *American Masters: The Voice and the Myth*, New York, 1973, p. 22.
19 Edward Hopper: 'Notes on Painting' (1933). Quoted from Goodrich, op. cit., p. 150.
20 O'Doherty, op. cit., p. 22.
21 ibid, p. 22.
22 Cf. Hopper's statement in *Reality*, Spring 1953, p. 8.
23 Goodrich, op. cit., p. 109.
24 For Hopper's links to symbolism in literature and art, see Levin, op. cit.
25 Quoted in Goodrich, op. cit., p. 133.
26 Flexner's unpublished letter to Hopper is quoted in Levin, op. cit.
27 Katharine Kuh: *The Artist's Voice. Talks with Seventeen Artists*, New York, 1962, p. 134. Quoted in Hobbs, op. cit., p. 129.
28 Cf. J[oseph] A[nthony] Ward: *American Silences. The Realism of James Agee, Walter Evans, and Edward Hopper*, Baton Rouge, 1985; and O'Doherty, op. cit., p. 19.
29 Cf. Gail Levin, *Edward Hopper. The Complete Prints,* New York 1979, p. 30.
30 Quoted in Gail Levin, *Edward Hopper as Illustrator,* The Whitney Museum of American Art, New York 1979, p. 7
31 Quoted in Lloyd Goodrich, op. cit., p. 30
32 Cf. Gail Levin: *Hopper's Places*, New York, 1985.
33 Cf. O'Doherty, op. cit., p. 21
34 ibid, p. 19.
35 ibid, p. 19.
36 ibid, p. 15.
37 ibid, p. 22.

The publishers wish to thank the museums, galleries, collectors and photographers whose assistance made this book possible. We particularly want to thank the Whitney Museum of American Art for their help and cooperation. In addition to the persons and institutions named in the picture credits we are also grateful to: Geoffrey Clements. N.Y. (pp. 2 and back cover, 6, 7, 9, 11, 12 [top], 15, 19, 21, 22, 33, 42 [top], 57, 58, 60 [left and right]); Robert E. Mates, Inc., N.J. (pp. 8, 12 [below], 13 [top], 13 [below], 16, 17, 18, 25, 81); Lee Stalsworth (p. 10); Ed Owen (p. 20); Stephen Kovacik (pp. 24, 66); Bill Jacobson Studio, N.Y. (p. 34); Malcolm Varon, N.Y. (p. 35); Mike Fischer (p. 63); John Tennant (p. 70 [top]); Otto Nelson (p. 72); Henry Nelson (p. 73); Steven Sloman, N.Y. (pp. 77, 94 [middle]); Joseph Szaszfai (p. 80); and Arnold Newman (p. 94 [right]).